CHERRY BLOSSOMS

Skira *Rizzoli*
NEW YORK

FREER | SACKLER
THE SMITHSONIAN'S MUSEUMS OF ASIAN ART

Late in the nineteenth century, at the suggestion of painter James McNeill Whistler, railroad magnate and art collector Charles Lang Freer turned his attention to Asia. Whistler's works had been greatly influenced by the art and culture of the East, especially Japanese woodblock prints, and he helped shape his friend and patron's collecting aesthetic. Freer saw his subsequent trips to dealers in Japan and New York City as opportunities to learn about Japanese culture while acquiring paintings, screens, prints, and ceramics.

When the Freer Gallery of Art opened to the public in 1923, its founder's Japanese screens were carefully displayed in a gallery that led to Whistler's paintings. East and West met symbolically in the first art museum to open on the Smithsonian campus in Washington, DC. Some sixty years later, the Freer would be joined by the Arthur M. Sackler Gallery, its sister institution, which contains collections of Japanese prints and paintings assembled by Robert O. Muller, Gerhard Pulverer, and others. These objects—examples of which are featured in the following pages—expand and enhance Charles Lang Freer's original vision.

Eleven years before the Freer Gallery opened, Japan had given the United States more than three thousand cherry trees, marking an important chapter in the relationship between the two countries. In commemoration, each year we celebrate spring and the arts of Japan with events for visitors of all ages. Tens of thousands of people visit the Tidal Basin to view cherry trees, much in the way our Japanese predecessors did so many decades ago, and gather under the cherry blossoms,

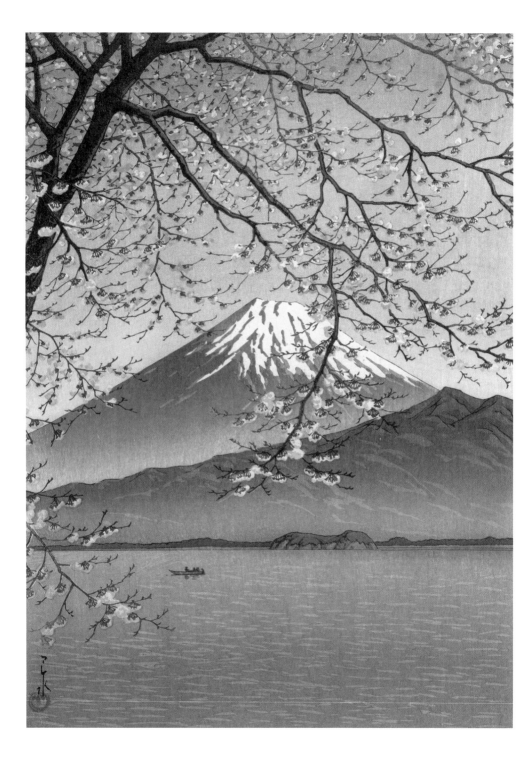

a sensual feast of color and fragrance. Then they head to the Freer and Sackler Galleries to gaze at the beauty of painted blossoms that never fade.

The fragile flower possesses a potpourri of meanings, celebratory and reflective, joyous and melancholic. No longer solely a Japanese tradition, cherry blossom festivities today are part of a worldwide celebration that's been more than a thousand years in the making.

Julian Raby
The Dame Jillian Sackler Director of the Arthur M. Sackler Gallery and the Freer Gallery of Art

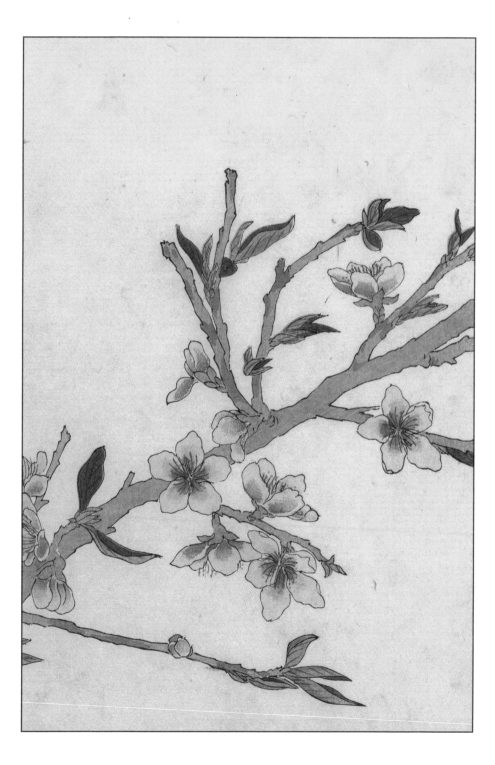

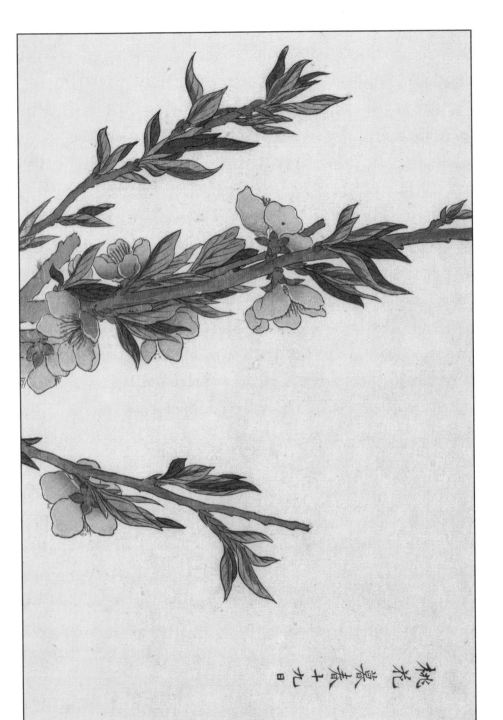

桃花暮春十九日

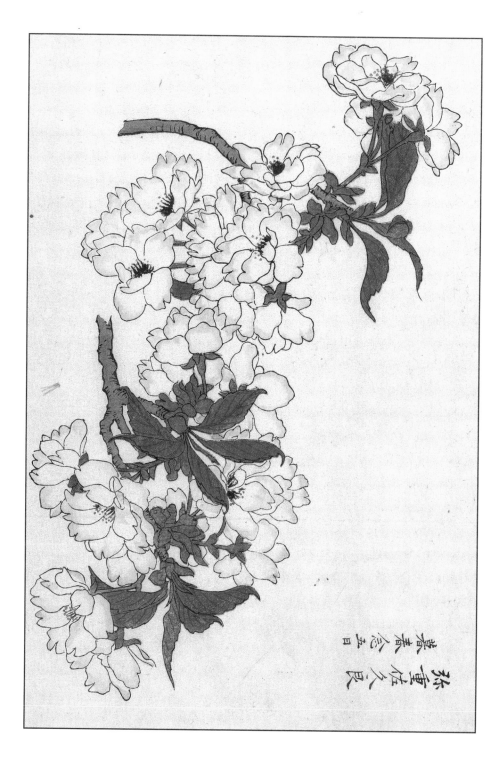

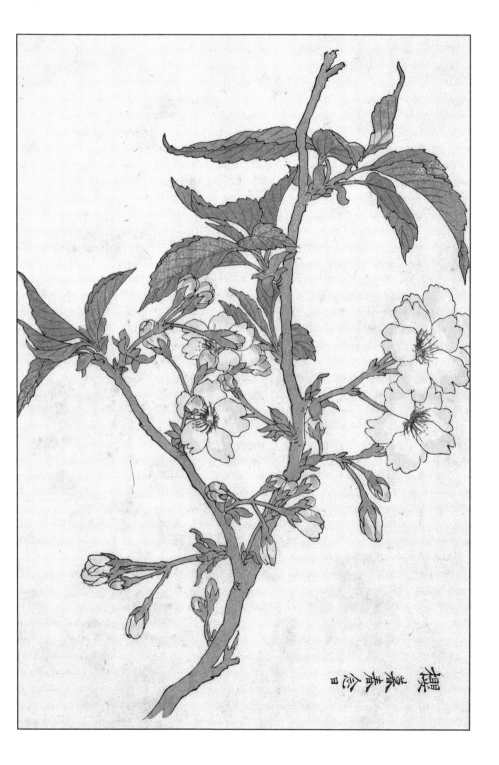

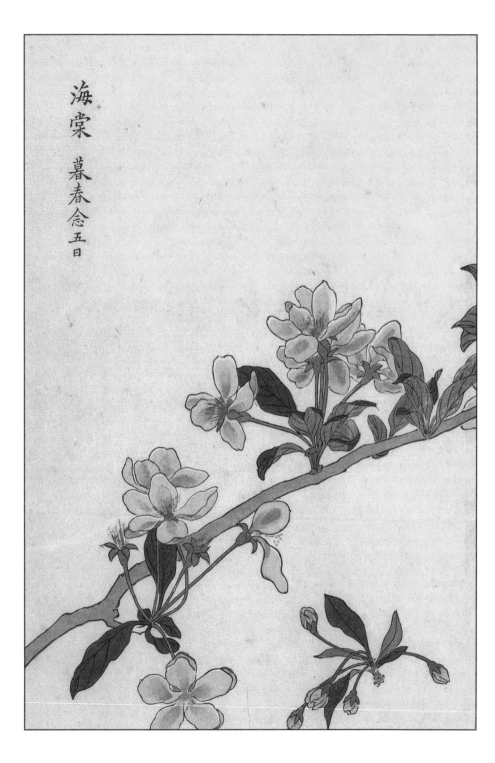

海棠　暮春念五日

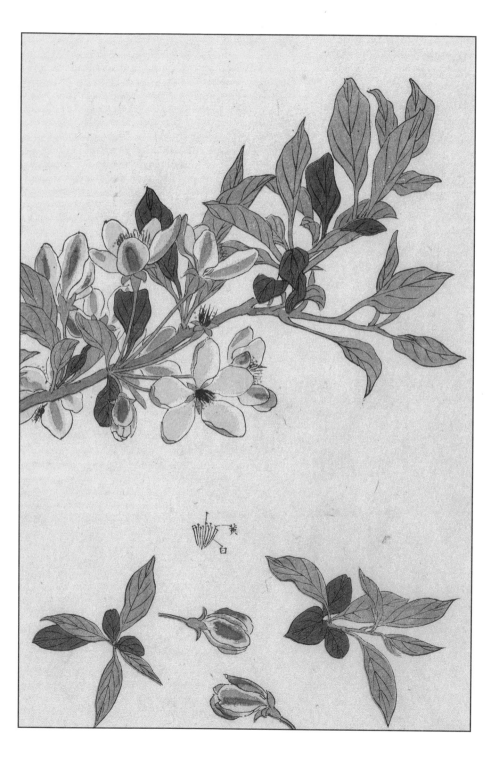

黄
白

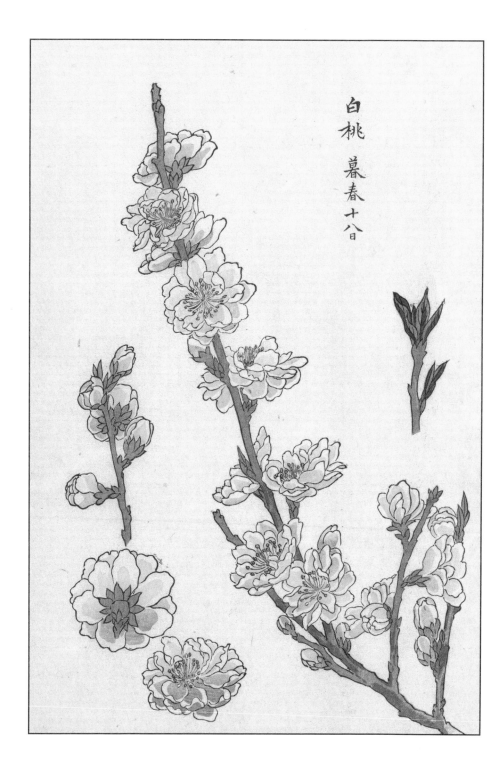

白桃　暮春十八日

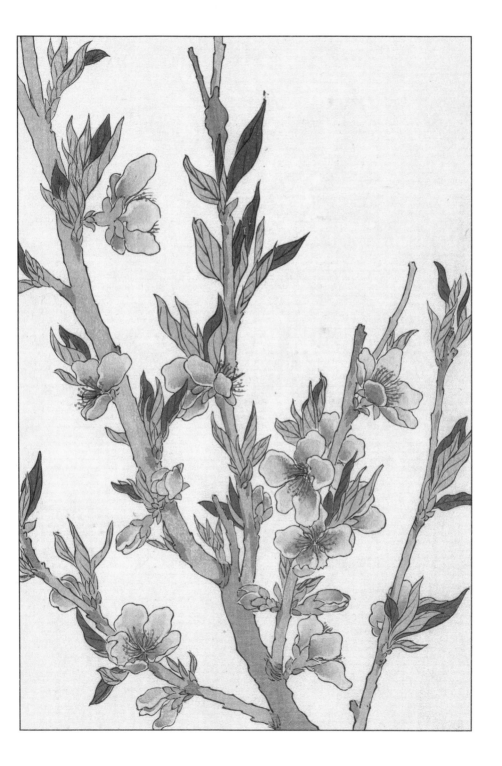

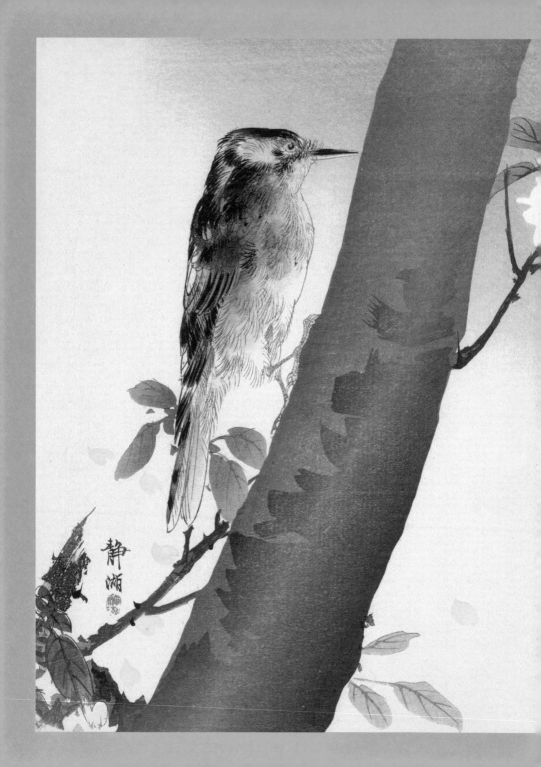

CHERRY BLOSSOMS

Asked about the soul of Japan,
I would say
That it is
Like wild cherry blossoms
Glowing in the morning sun.
Motoori Norinaga

From the moment their buds appear to the time when the elegant petals fall, cherry blossoms have a special place in the hearts and minds of the Japanese people. The appearance and disappearance of the blooms have become imbued with meaning and have helped to shape a distinctly Japanese aesthetic, one that favors beginnings and endings, simplicity, and perhaps most unusual of all, perishability. Cherry blossoms represent that and more. In describing Japanese culture, scholar Donald Keene once referred to the modern "cult of cherry blossoms" and how their importance registers with all members of Japanese society: "Radio announcements inform the breathless public at which sites the blossoms are eight-tenths opened and at which only seven-tenths, and eager busloads of factory workers head for the suitable spots." Indeed, Japan is a nation swept away by cherry blossoms.

Whether viewed in nature, painted by the hand of a master, designed for woodblock prints, or described through the eyes of a poet, the pink and white petals of the cherry blossom represent more than a celebration of a season. Their brief existence—from buds about to flower to fully ripened cherries in full bloom—aligns with themes of transience, fleeting beauty, and the brevity of days. Akin to the larger cycles of life

and death, the flowers may look the way they did in the ninth century when poets began to praise their beauty, but the symbolism and significance surrounding them have transformed over the centuries, encompassing the best and sometimes the darkest moments of life. How did a flowering tree come to be associated with individual yearns and aspirations as well as with the soul of a nation?

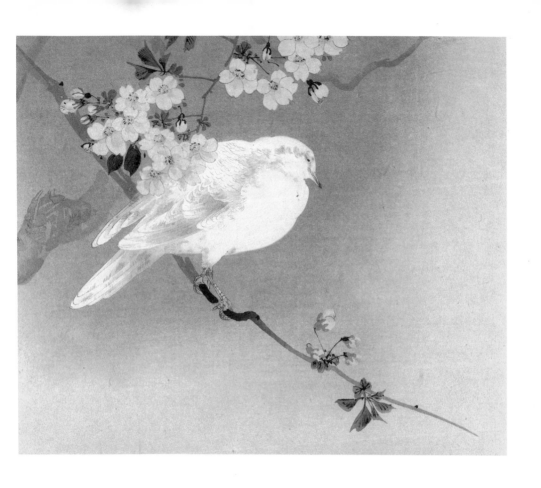

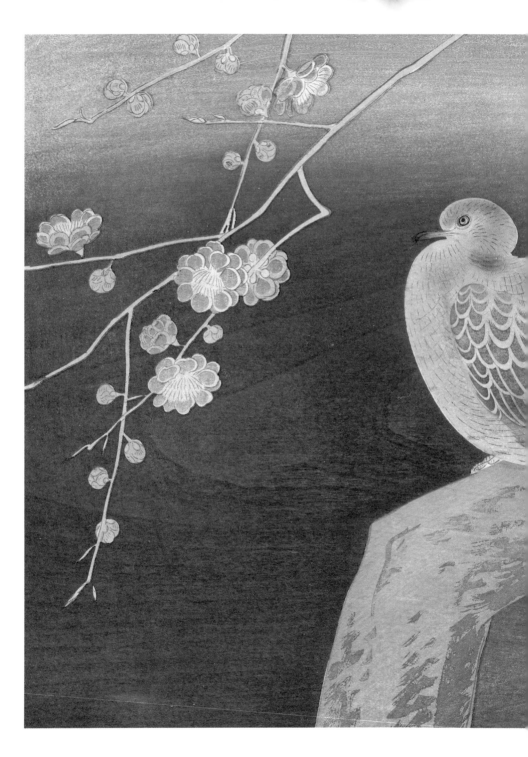

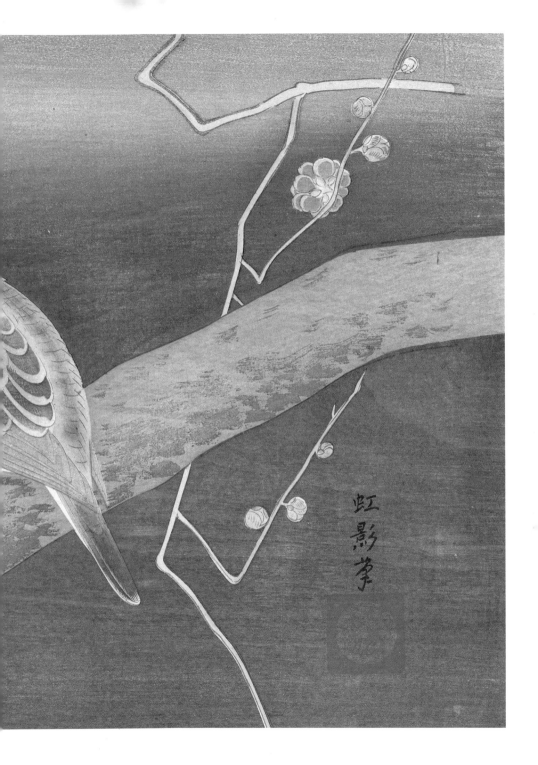

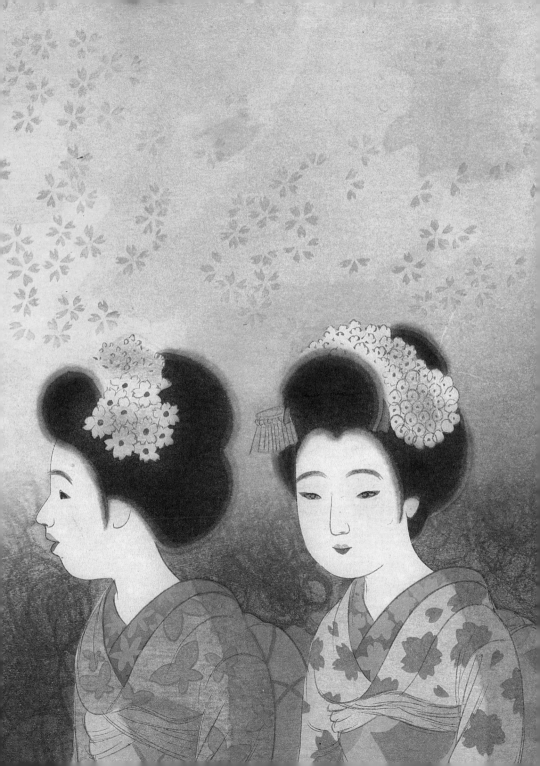

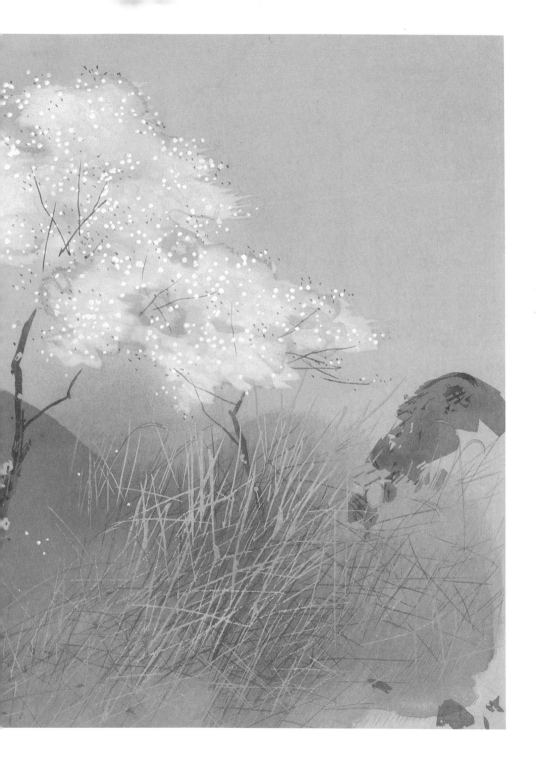

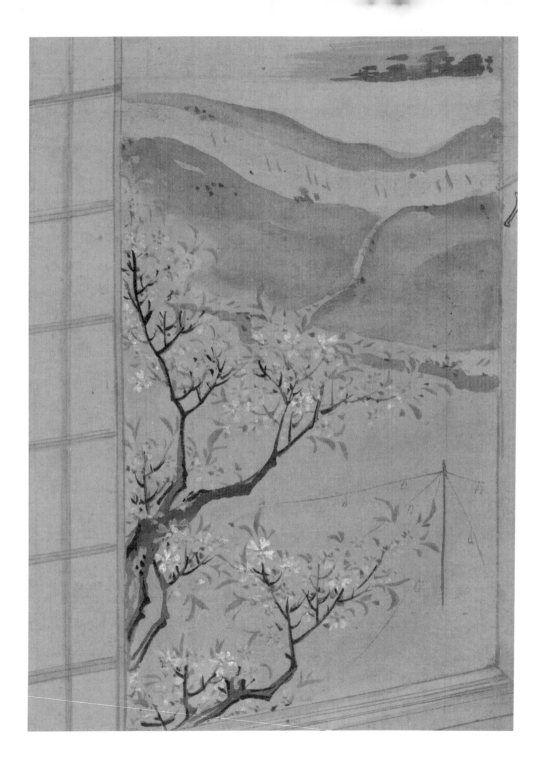

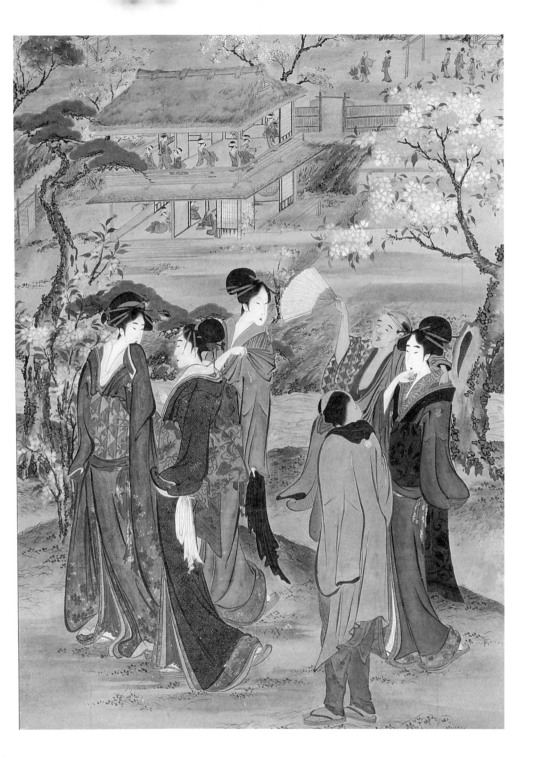

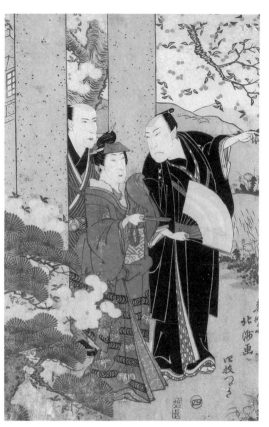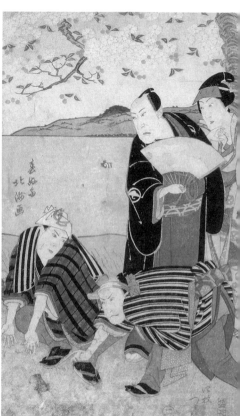

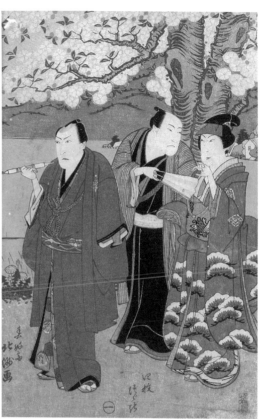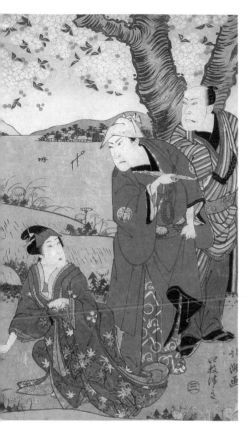

京
唐橋
村雄

日此
影の
えぐつめ
本立ち
ふくろうも
同も
ゑんゆる
うつと
抑のふ
まてらき

桐政女

家ごとの
楼の枝も
ほのと
あと
はけられた
鐘の
地ひ
まる

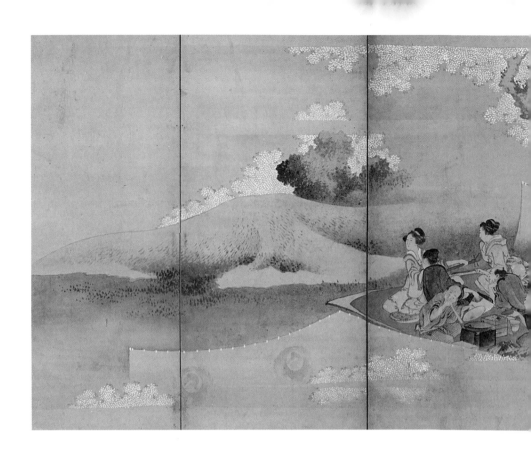

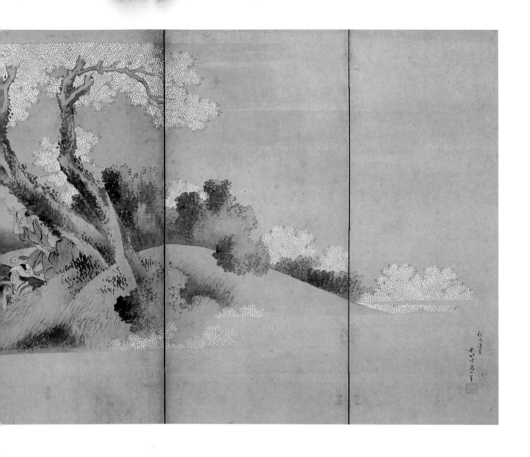

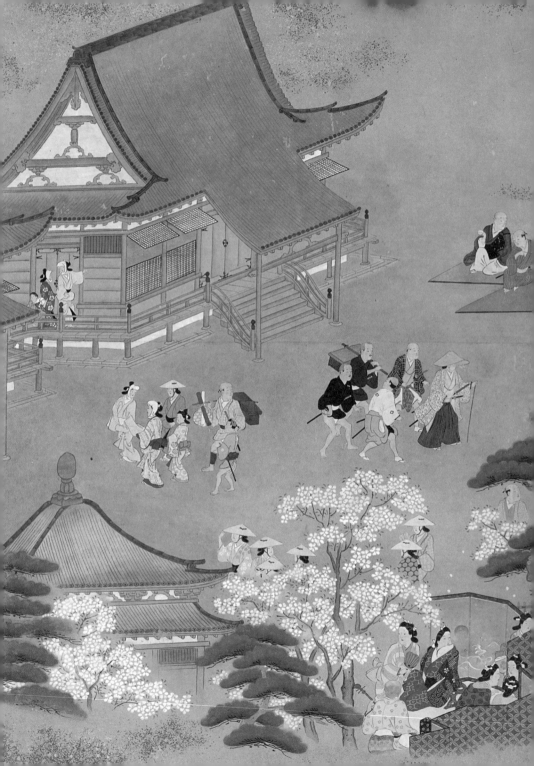

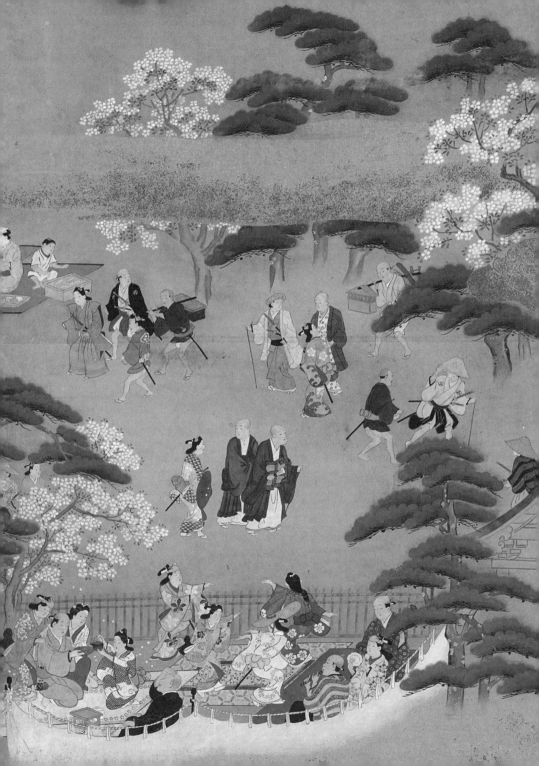

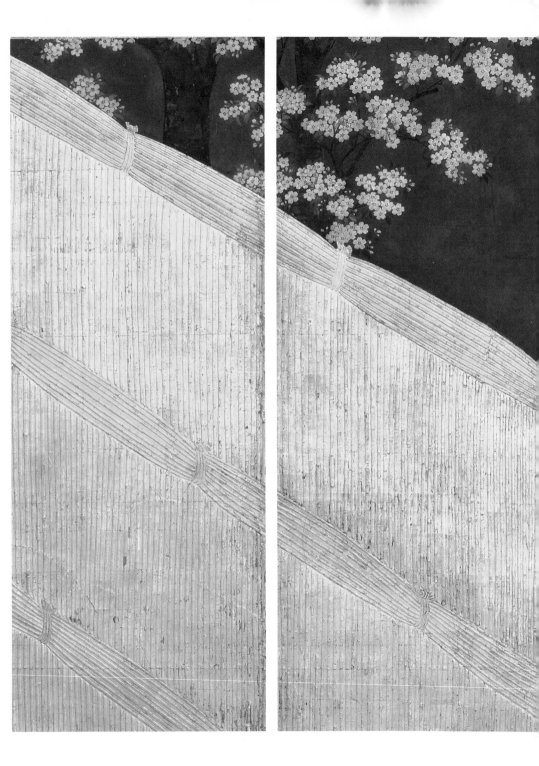

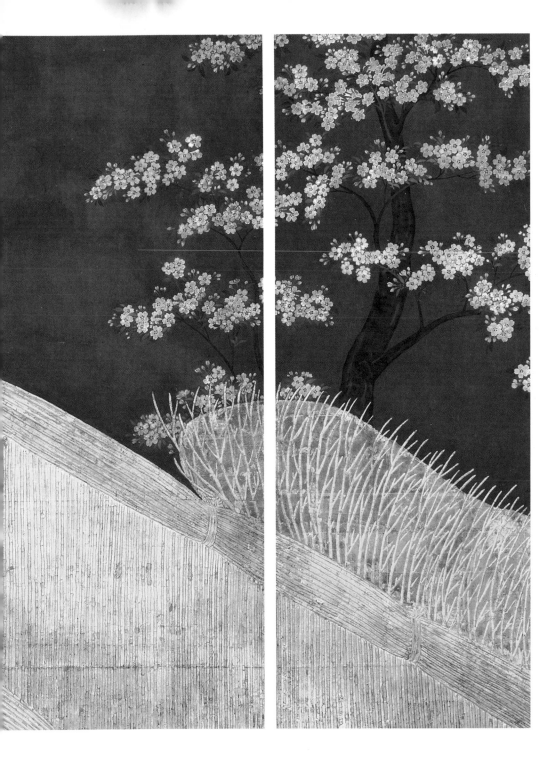

CHERRY BLOSSOMS

In eighth-century Japan, during the Heian period (874–1185), a sophisticated literary culture flourished in the shadow of China, still under the sway of the once-mighty Tang dynasty (618–907). Educated Japanese people emulated Chinese customs and literary traditions, including an appreciation for the blossoming plant that announced the lunar new year in February—the plum, with its optimistic buds pushing through winter snow. With the gradual indigenization that turned Chinese symbols into Japanese realities, a new flowering plant gained popularity—the cherry blossom, a harbinger of spring. Illustrating the plant's ascendant status, in 834 Emperor Ninmei had a cherry, rather than the usual plum, planted in front of the main hall of the imperial palace. Plum trees, which flower months earlier than cherry blossoms, bore none of the latter's complex associations with beauty and ephemerality.

Japanese Buddhism was at the heart of most literature in the eighth century. Nature was seen as a mirror of life and human personality. Seasons were celebrated, natural life was examined, and the cherry in its various stages, from bud to decay, captured life's joys, vicissitudes, and inevitabilities. In the tenth and eleventh centuries, images of the tree in bloom corresponded to an emerging aesthetic sensibility—a combination of Buddhist notions of impermanence and an affinity for the seasonal beauties of Japan's natural world. In turn, the changing seasons became a reflection of the emotions of the human heart.

Cherry blossoms and blossoming trees soon were featured in both Buddhist and narrative paintings. In *The Tale of Genji*

by Murasaki Shikibu, themes such as the passage of life and karmic cycles were depicted by cherry trees in bud, in bloom, and nearly bare. Illustrated hagiographies often showed holy people in spring landscapes and amid an abundance of cherry blossoms. In the late sixteenth and early seventeenth centuries, the beginning of the efflorescence of the Japanese multifold screen, the cherry tree became even more prominent.

From that time forward, people paid special attention to *hanami*, the custom of viewing cherry blossoms in the spring and its associated maple-leaf viewing in the fall. Indeed, the custom of *hanami* in practice and depiction gained particular momentum in the Edo period. Families gathered under the weight of the full blooms as if they were standing under fragrant clouds. As the centuries passed, and the Japanese became more urban, the cherry evolved into a popular and celebratory image, gradually moving away from its overtly Buddhist connotations.

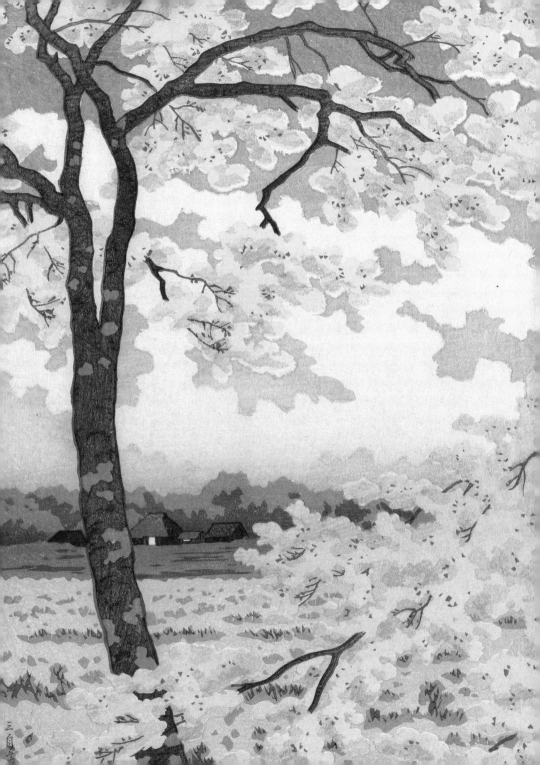

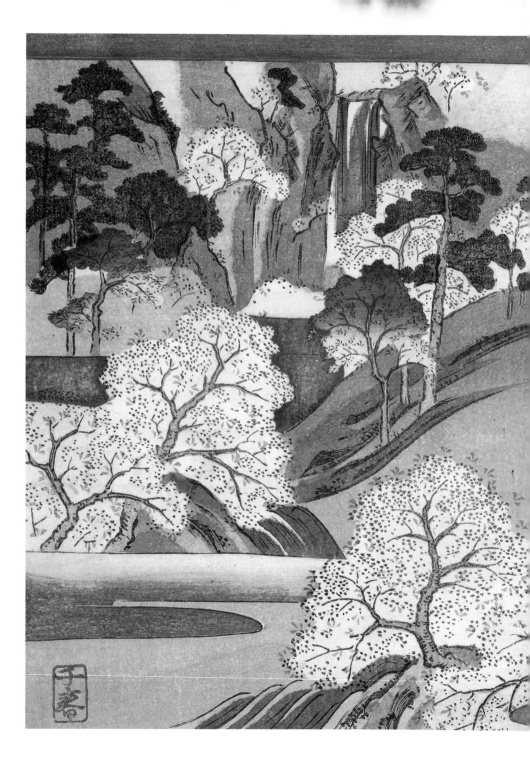

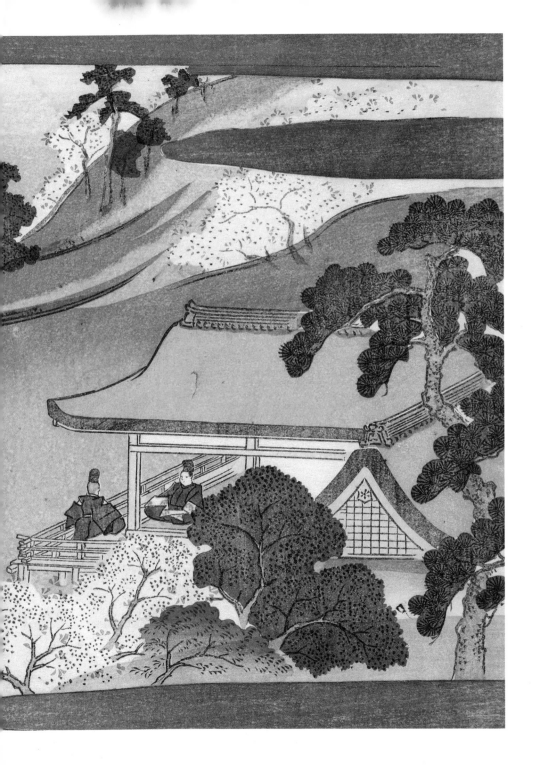

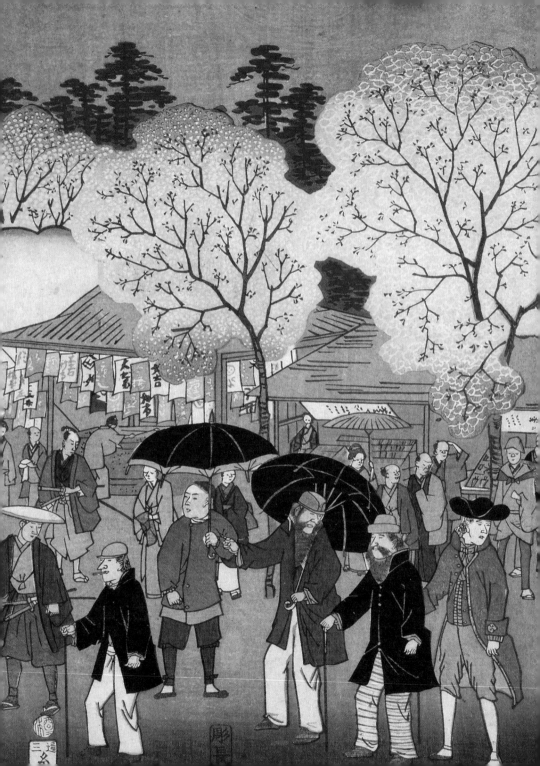

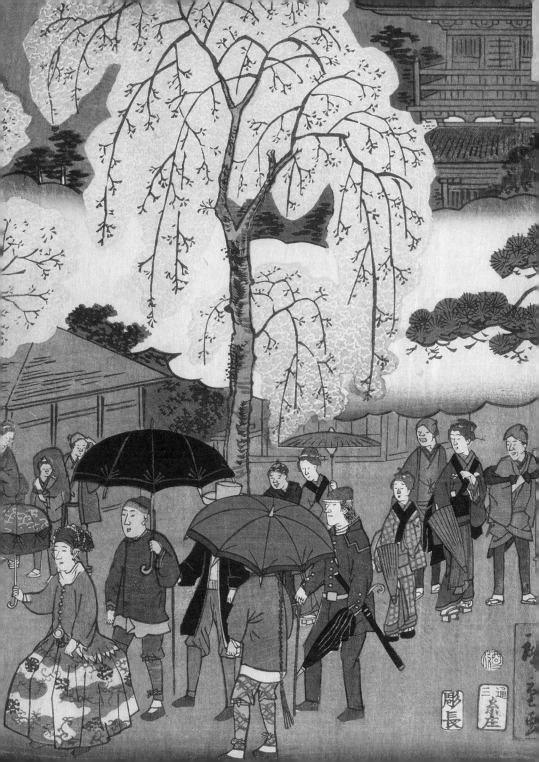

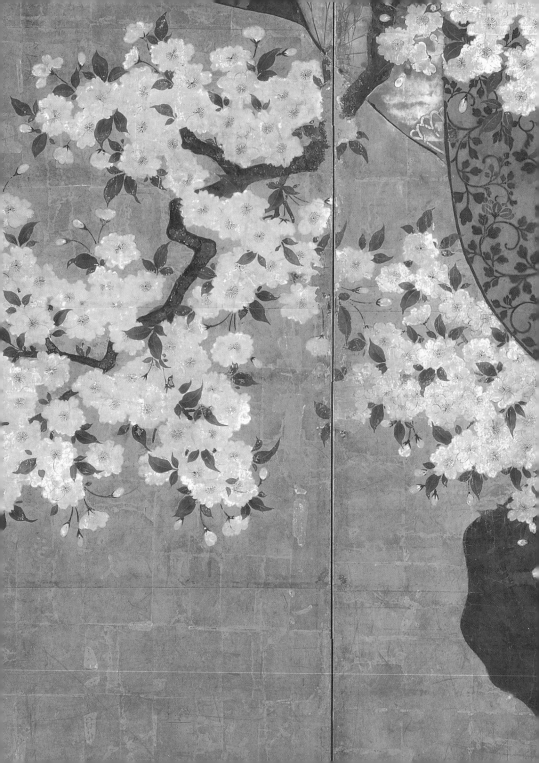

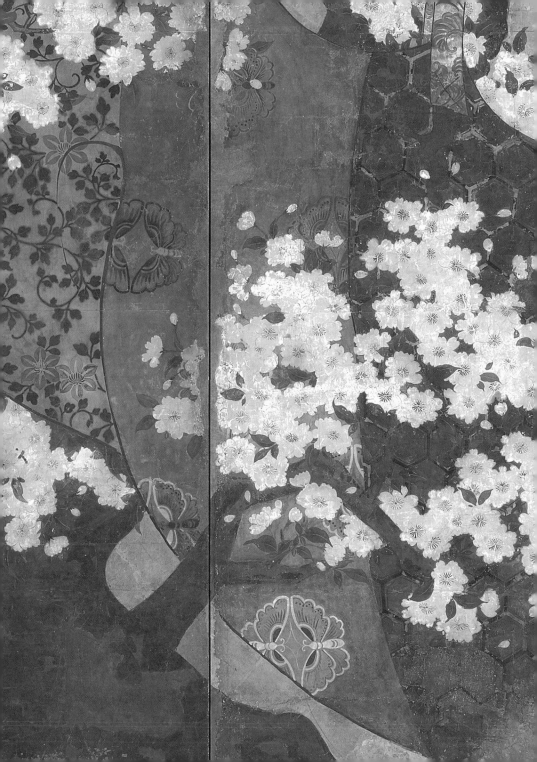

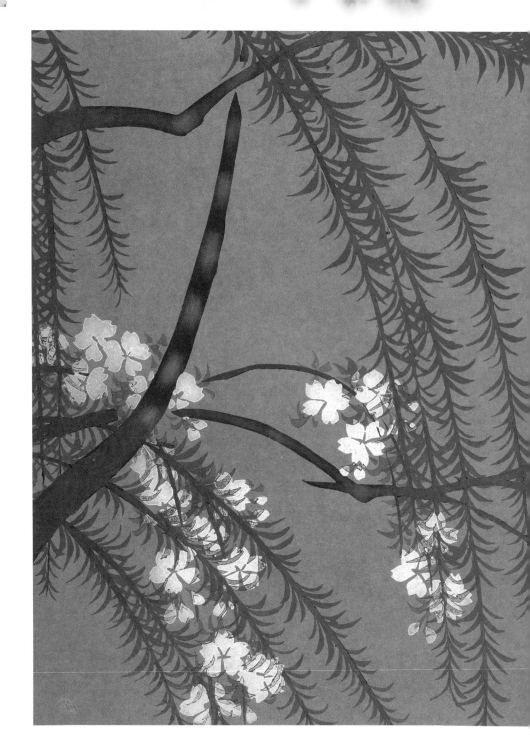

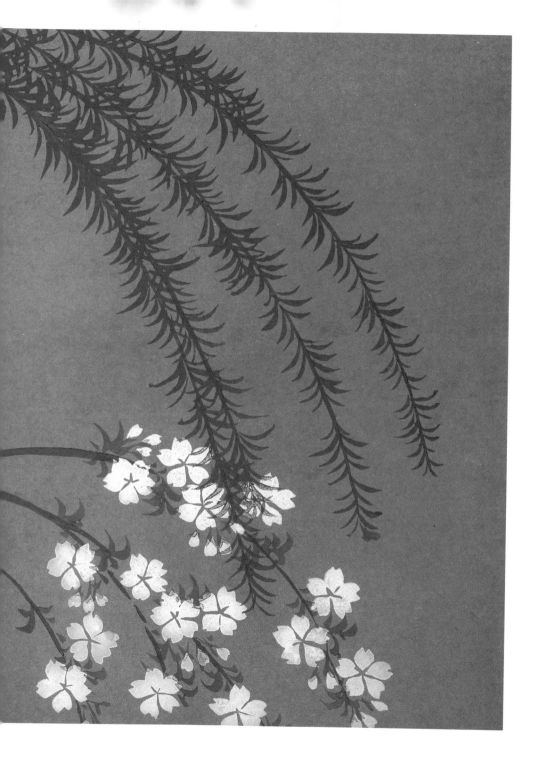

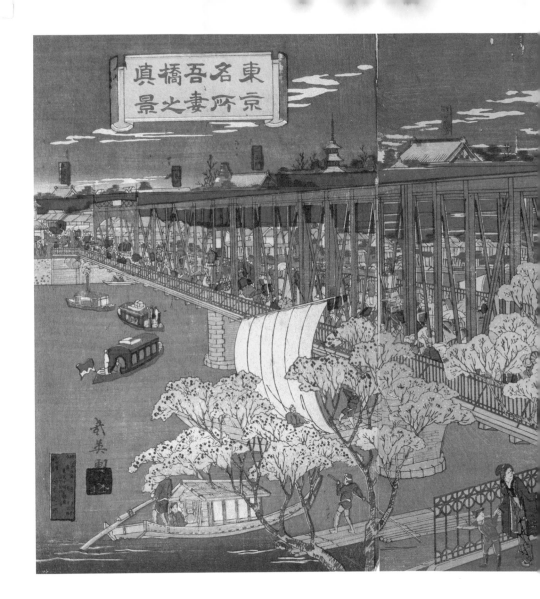

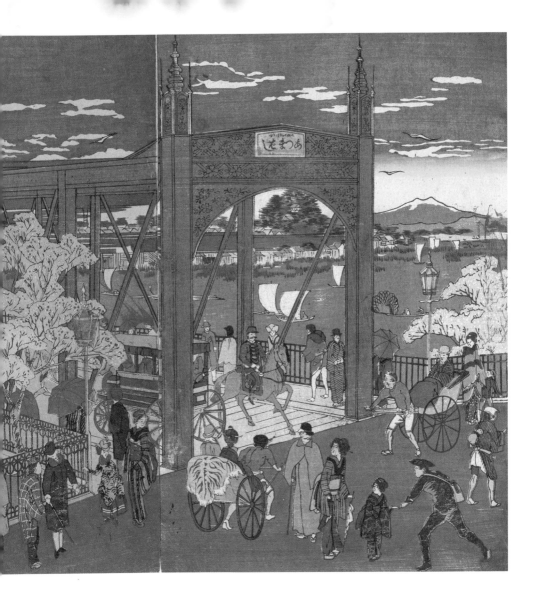

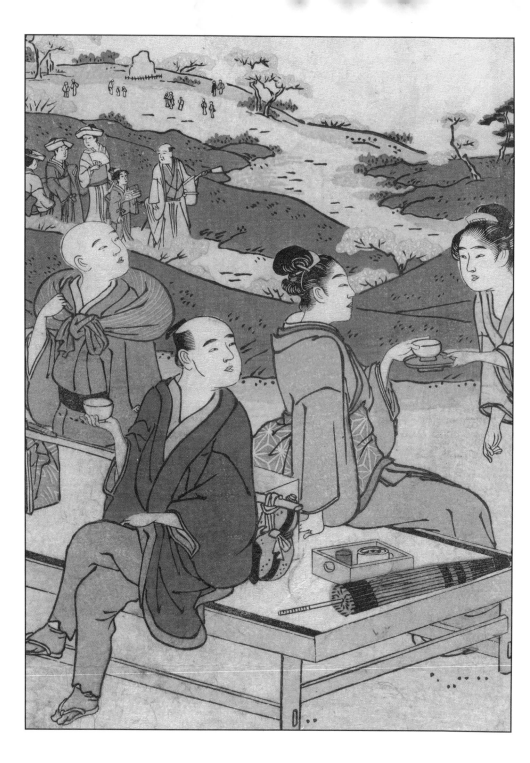

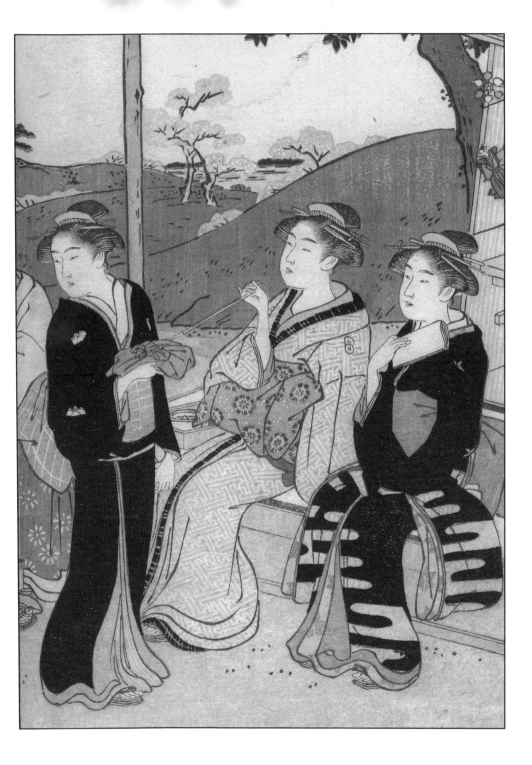

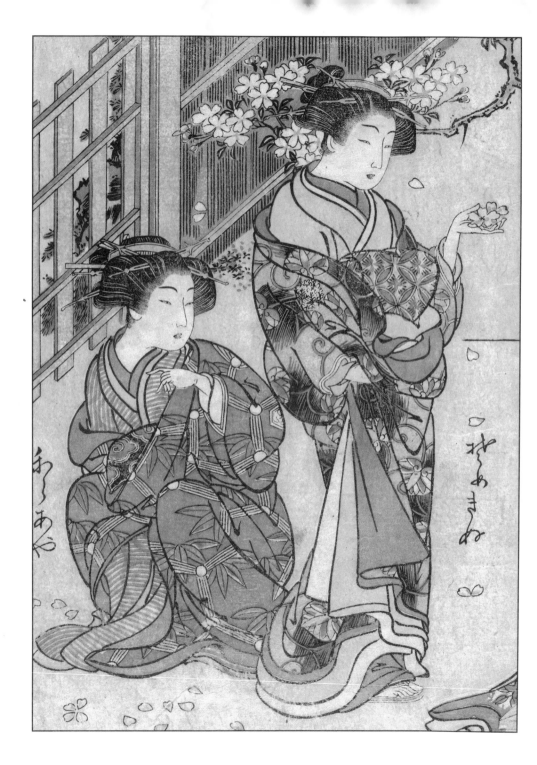

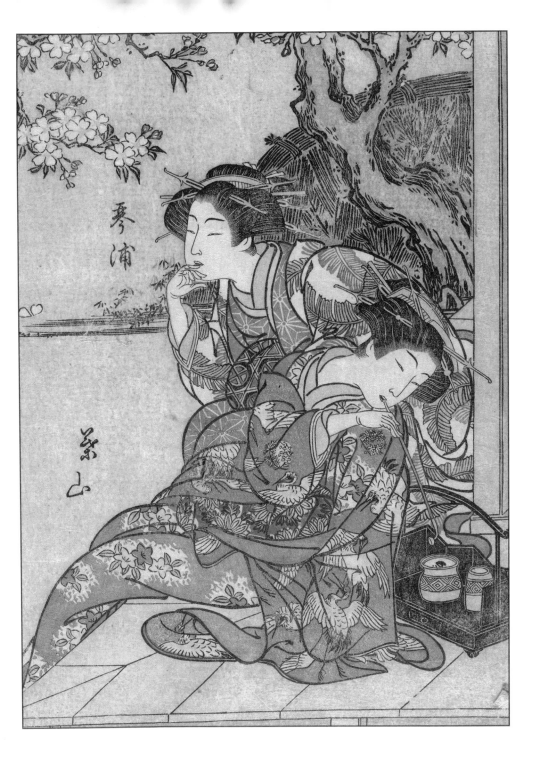

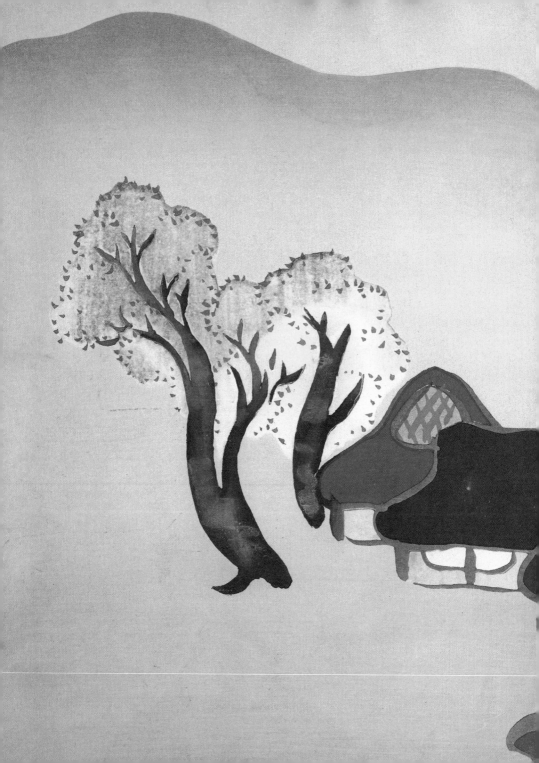

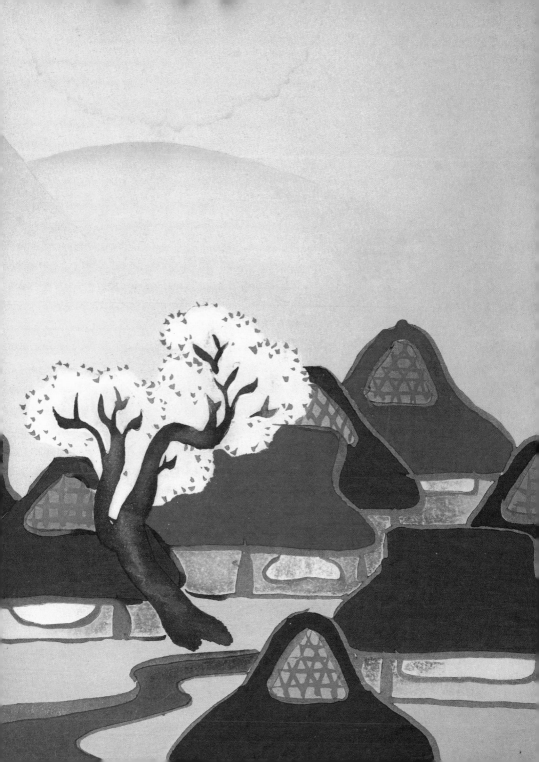

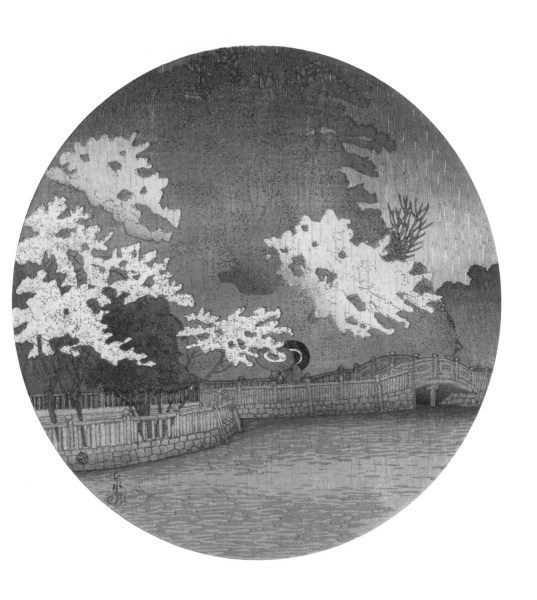

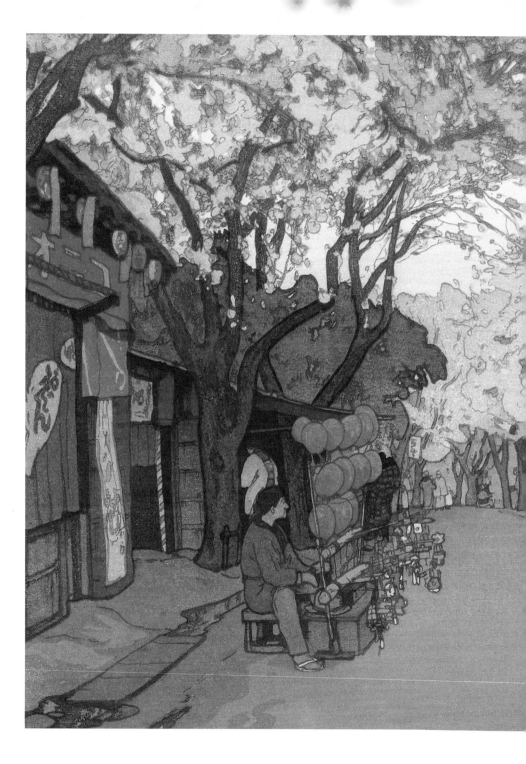

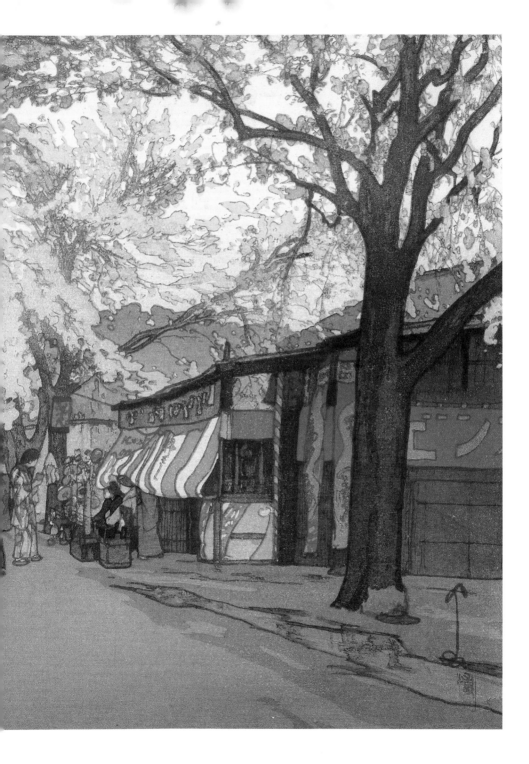

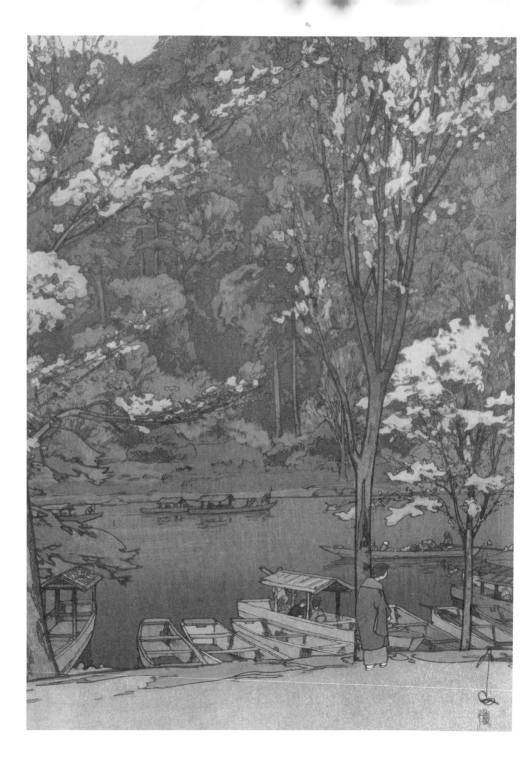

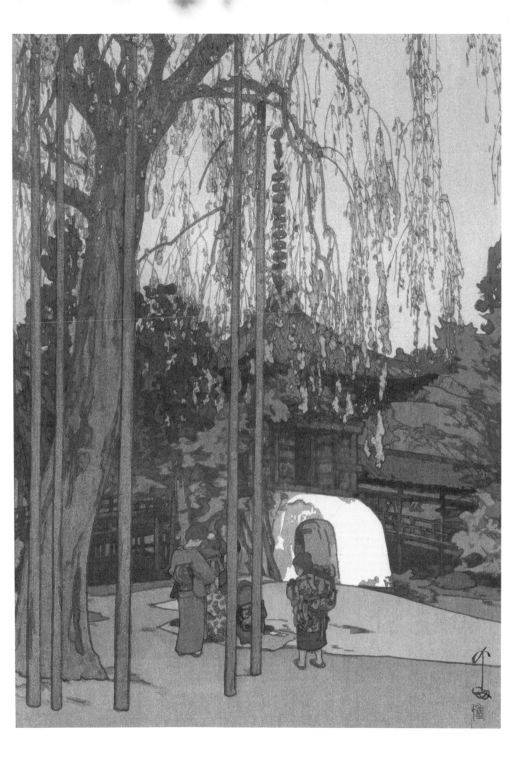

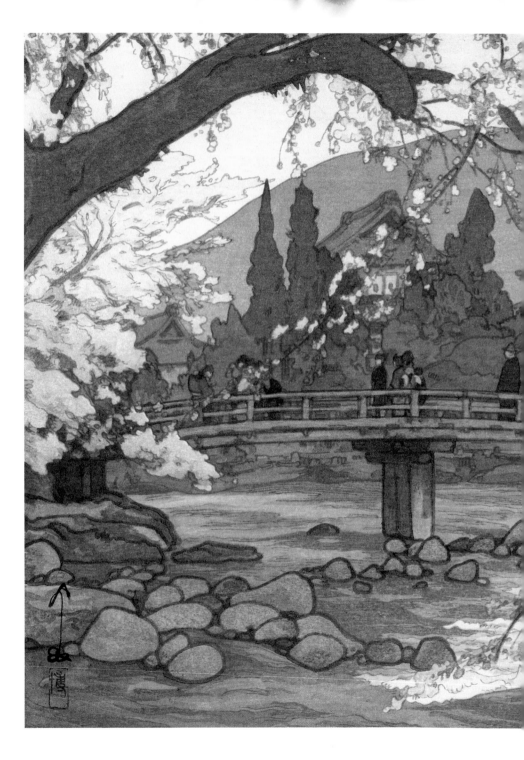

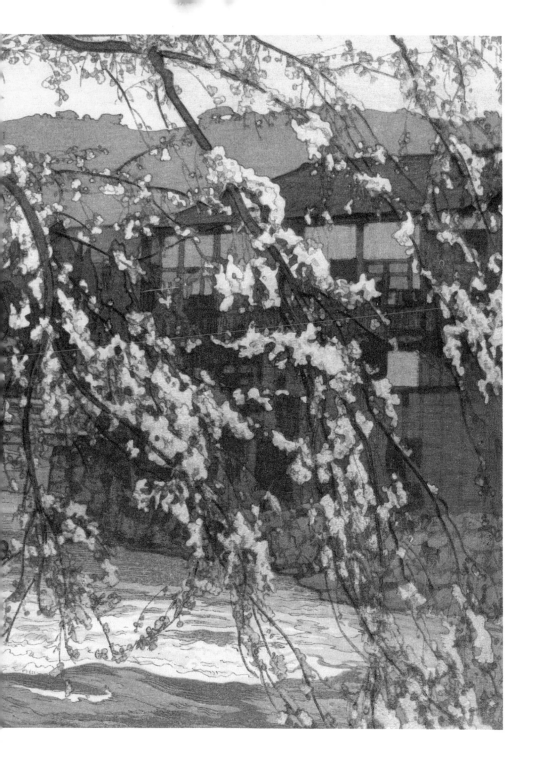

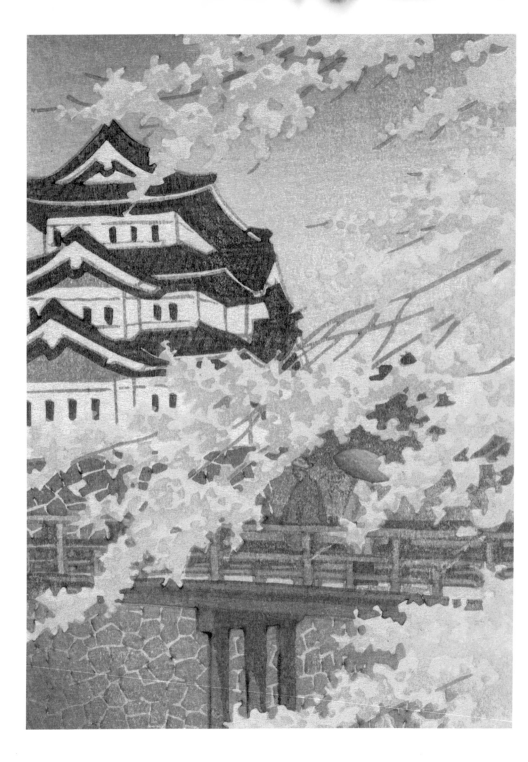

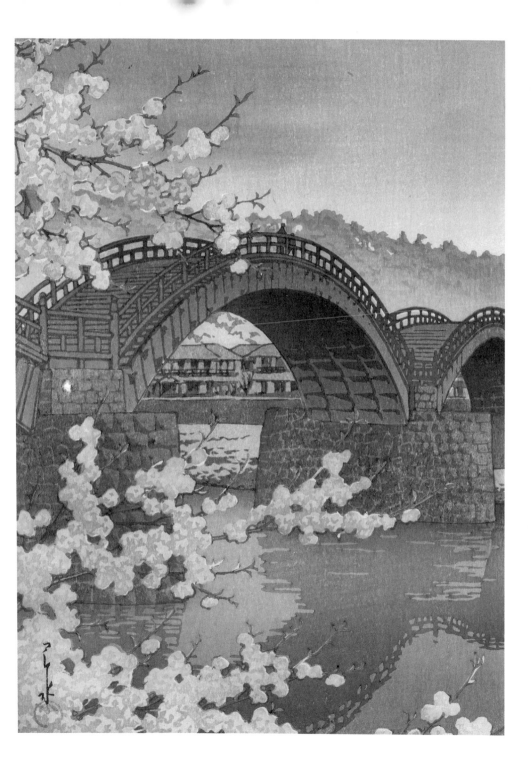

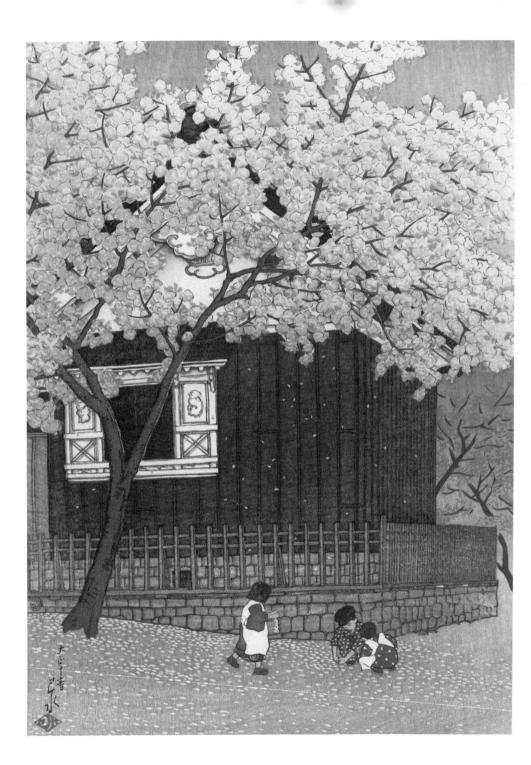

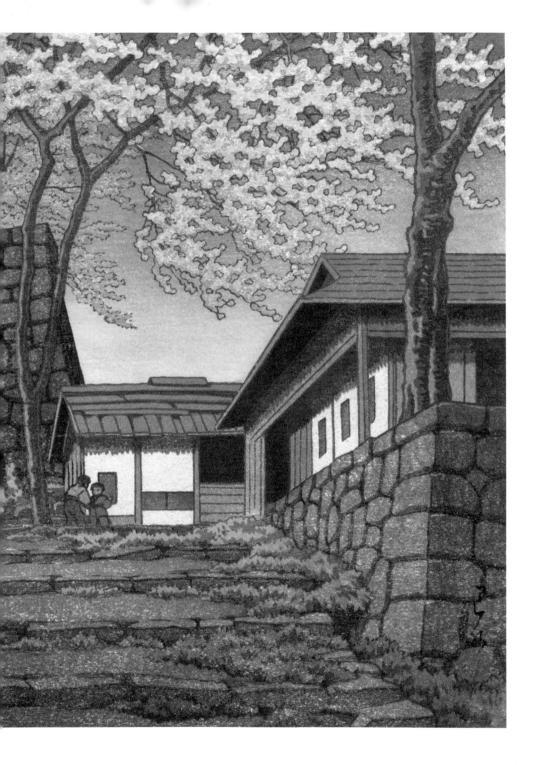

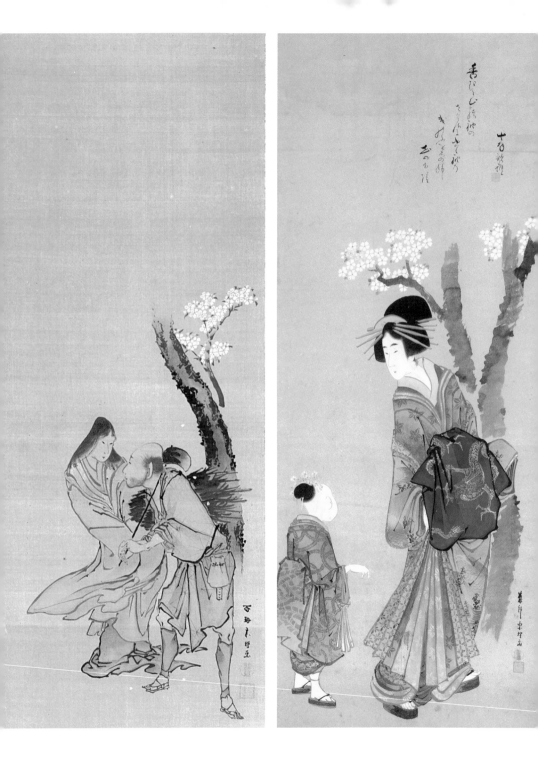

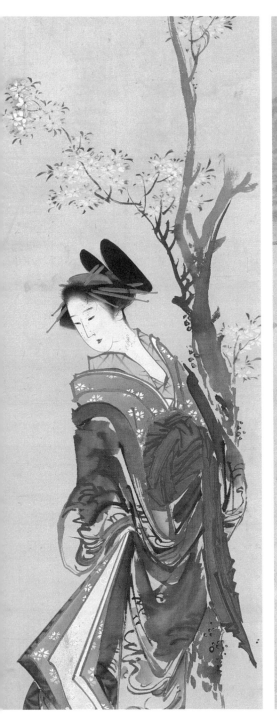
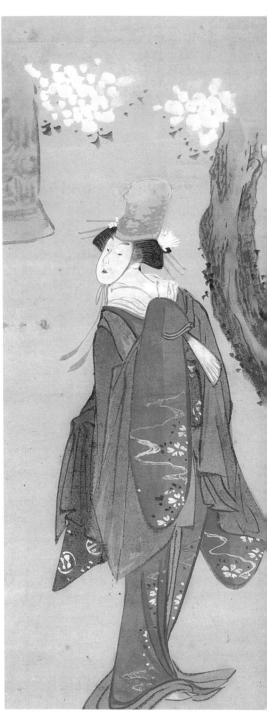

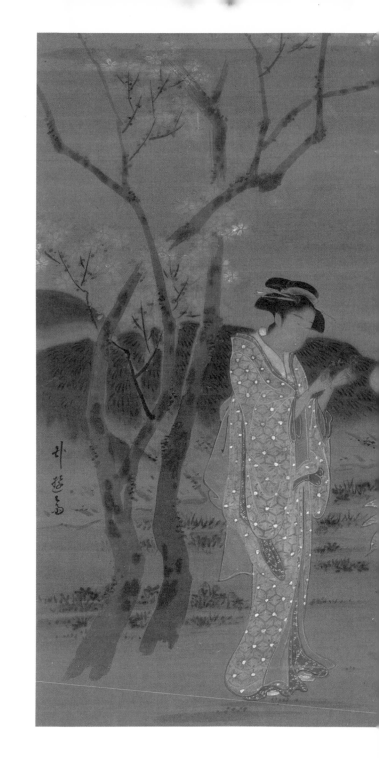

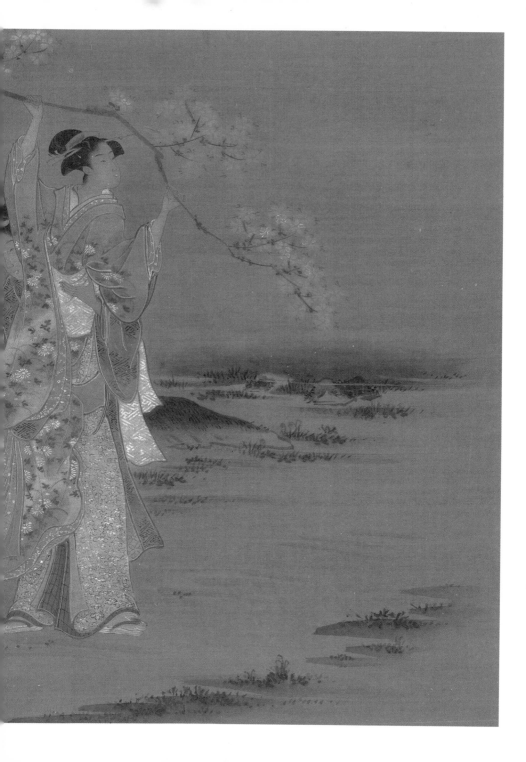

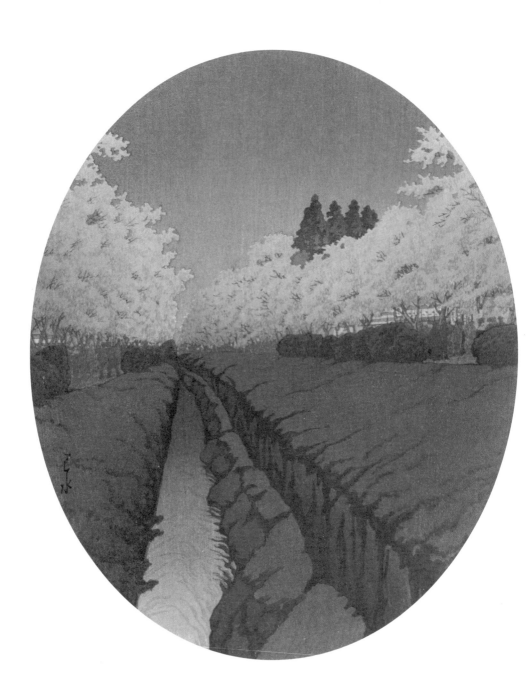

CHERRY BLOSSOMS

Under cherry trees
Soup, the salad, fish and all...
Seasoned with petals
Matsuo Basho

Cherry blossoms fall, as poet Matsuo Basho describes, not just
on the people at a viewing party but on their picnic as well.
Basho's poem has a carefree elegance to it, evocative of time
and place: it's easy to imagine yourself under petals that have
fallen around you, on you, and on your meal. Basho was
a master at weaving the eternal with the quotidian. He cap-
tures a moment that won't last: evanescence and transience
under falling cherry blossoms. The haiku's seventeen syllables
seem to mirror the cherry's brief life, the perfect literary form
for ephemerality.

Preceding Basho by a century and lasting into his lifetime,
a genre of painting depicted slips of decorated paper known
as *tanzaku*. Inscribed with lines by revered poets or with
verse composed on the spot, the papers were attached to tree
branches by members of viewing parties. In the paintings,
the people have departed, and all that is left are the immortal
words among cherry blossoms.

When Japan opened its doors to foreigners in the nineteenth
century, the West was mystified. Here was a country that
embraced modernization and militarization, yet hid behind the
persona of the delicacy of tea. In the Meiji period (1868–1912),
Japanese merchants sought ways to provide a simplified and
clear code for the outside world to interpret the nation's opaque

culture. In this popular public relations effort, the cherry tree and its blossoms, as well as Mount Fuji, became synonymous with Japan.

> *What a strange thing!*
> *To be alive*
> *Beneath cherry blossoms*
> Kobayashi Issa

The cherry blossom has always been associated with beauty; when falling, it is a reminder of the passage of time, of loss and sadness. In the eighteenth and nineteenth centuries, the blossoms became infused with nationalist notions. During the Russo-Japanese War (1904–5), they were used on flags and buntings; once the harbinger of beginnings, the cherry blossom was linked to the notion of dying for one's country. This escalated in the 1930s when young heroes were again sent off to war. Japanese military propaganda leading up to and during World War II described the sacrifices of soldiers and especially pilots who, dying in flight and falling from the sky, were compared to cherry blossoms. The flower became a metaphor for young and beautiful lives extinguished. What was once a symbol of the ephemeral evolved over the course of millennia to become an essential symbol of Japanese culture.

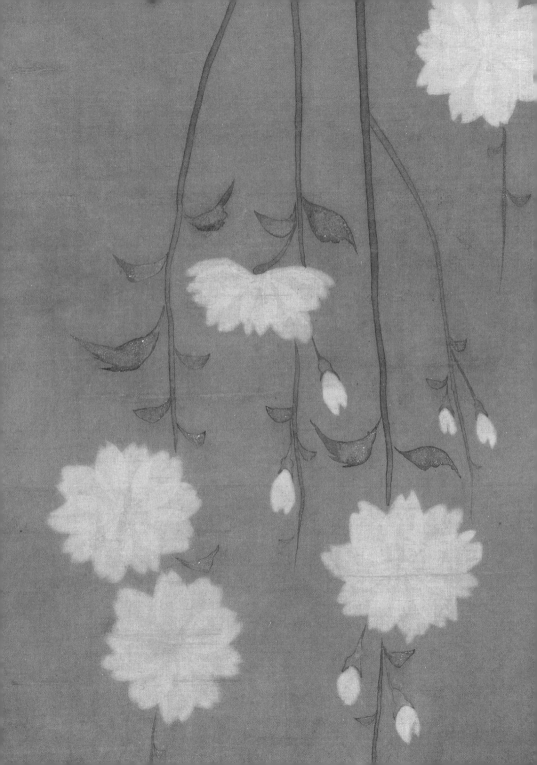

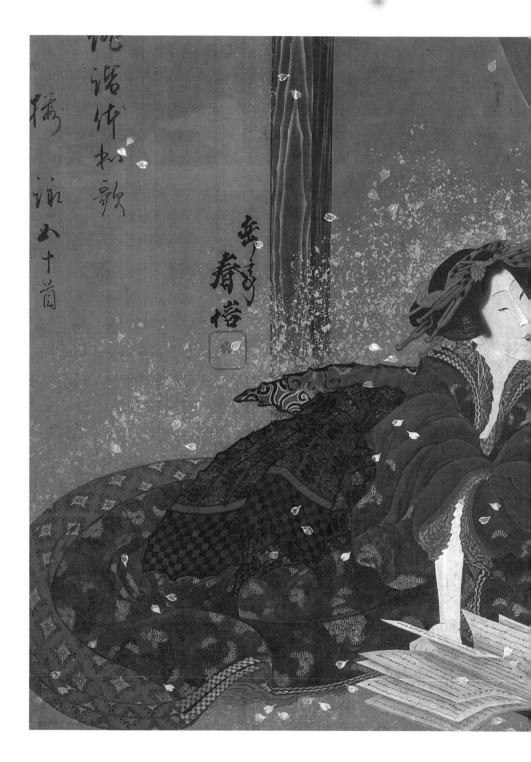

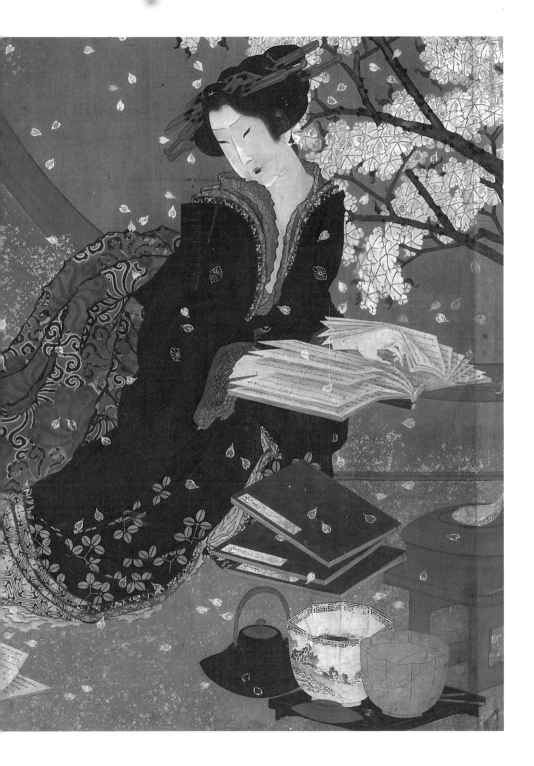

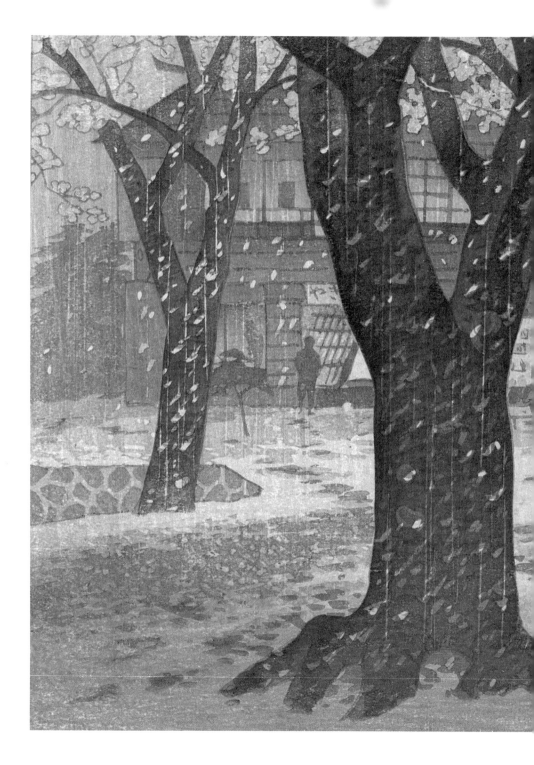

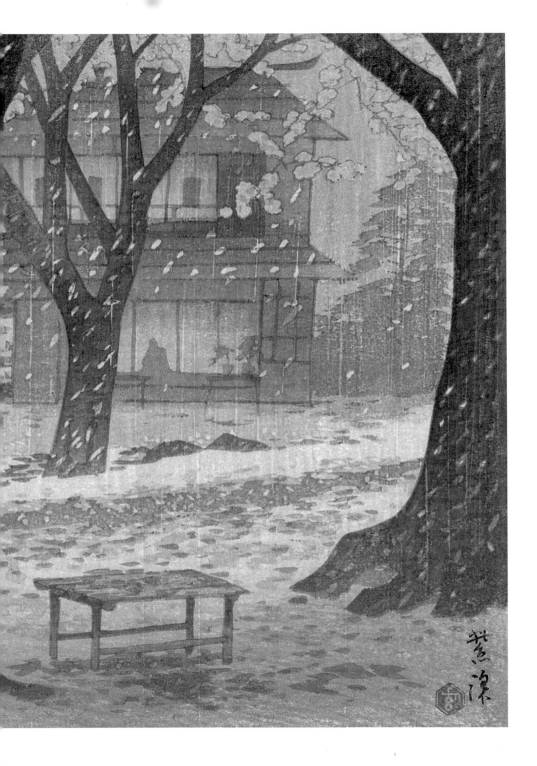

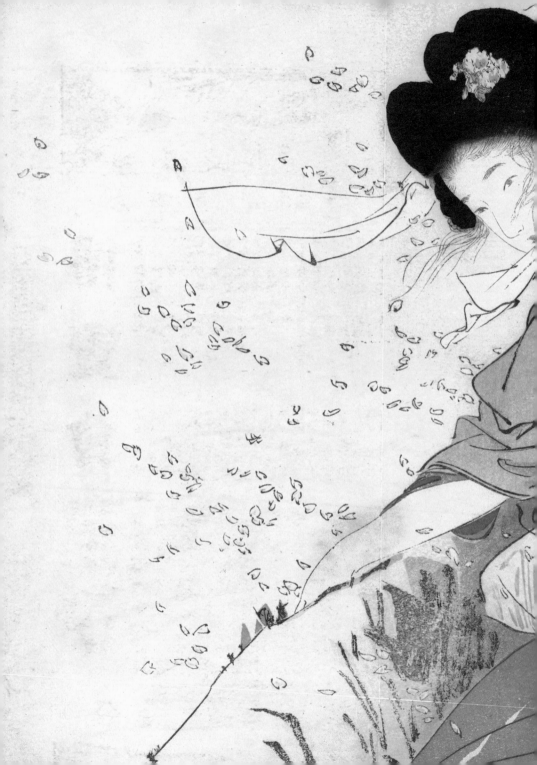

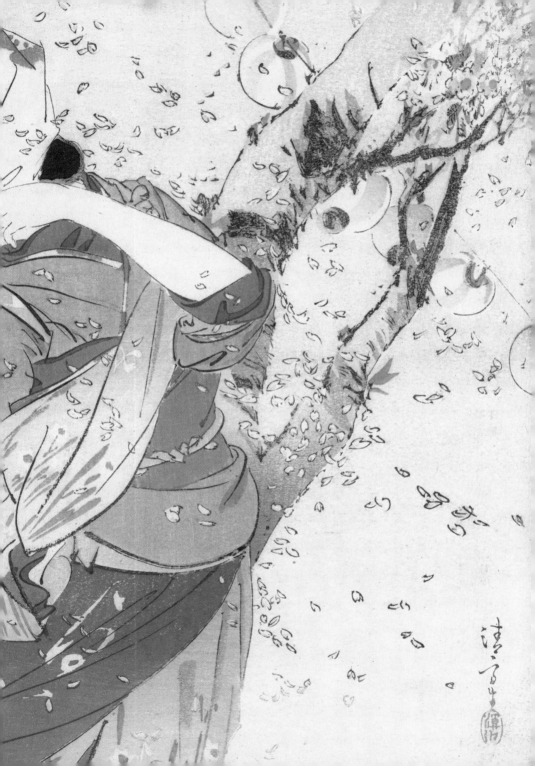

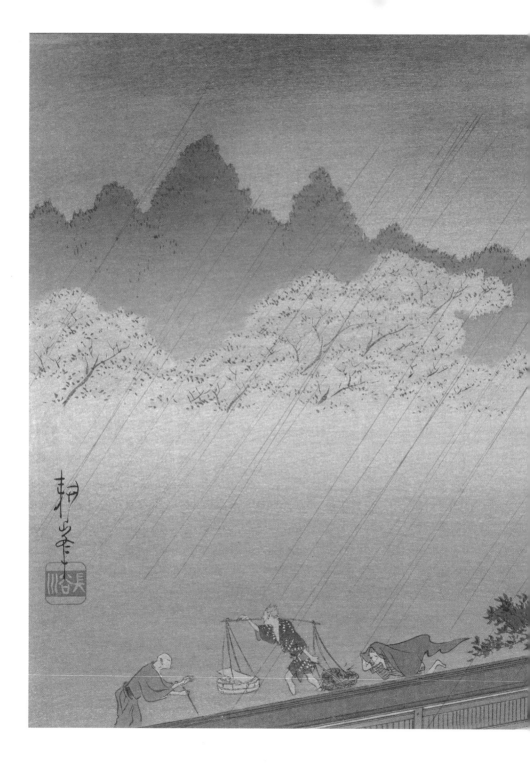

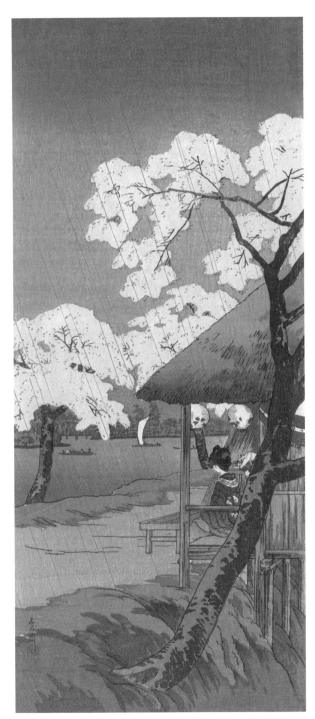

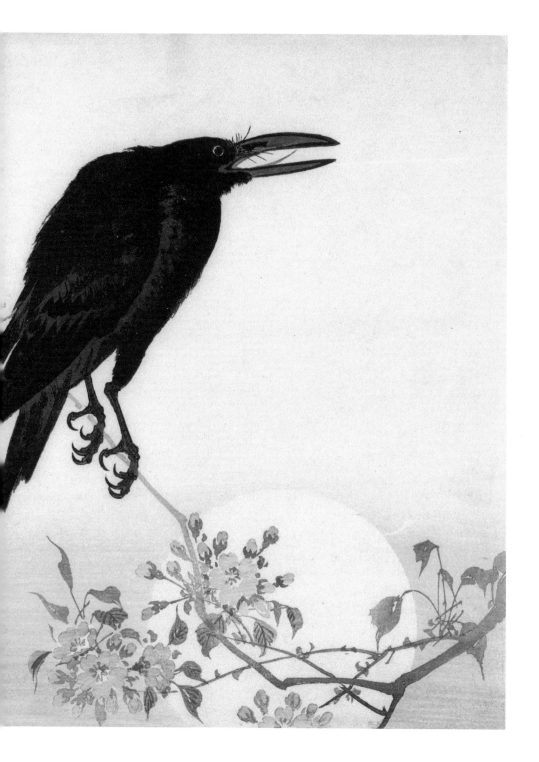

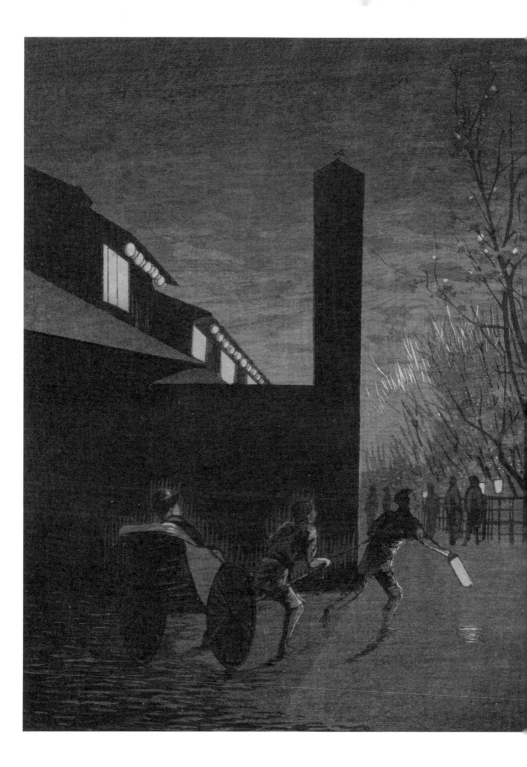

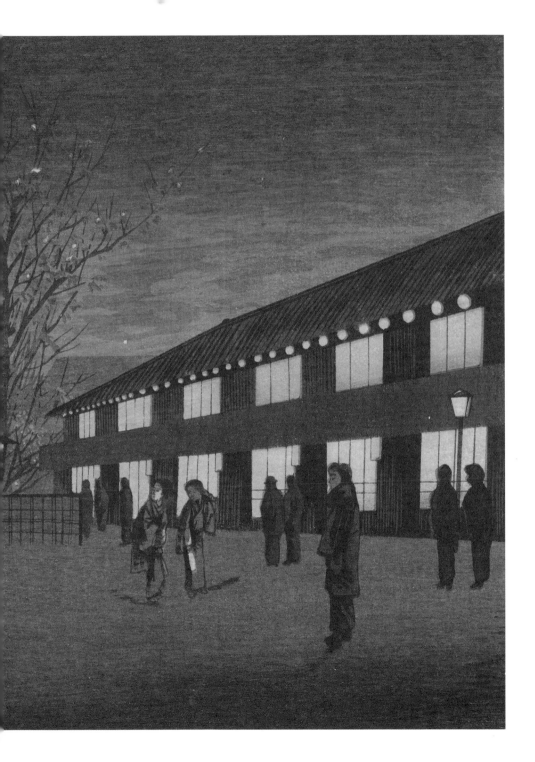

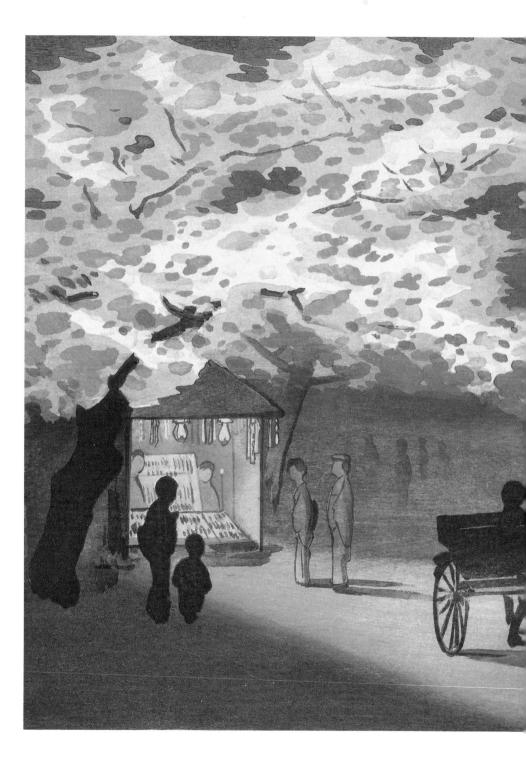

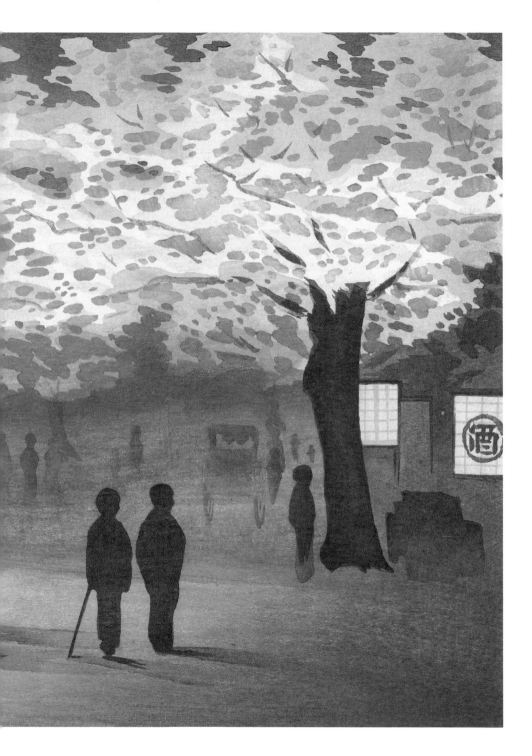

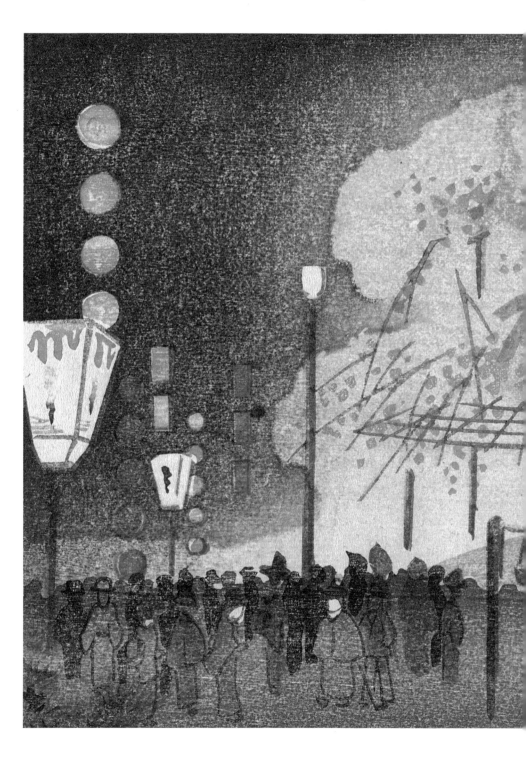

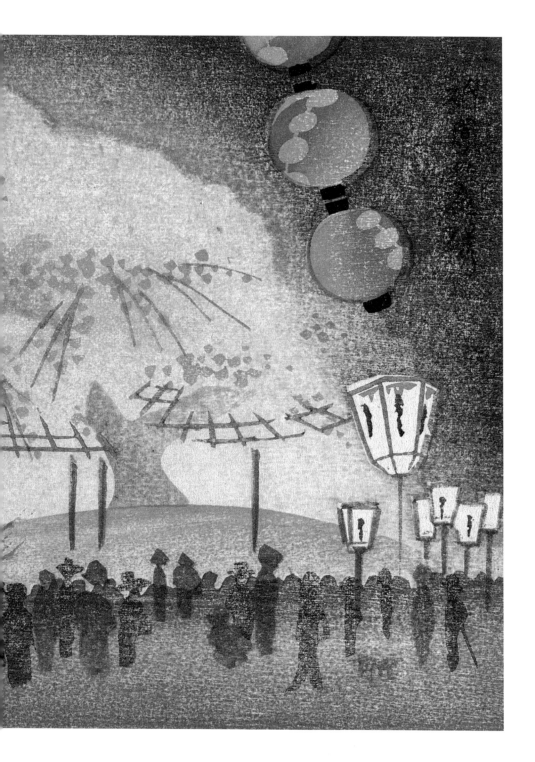

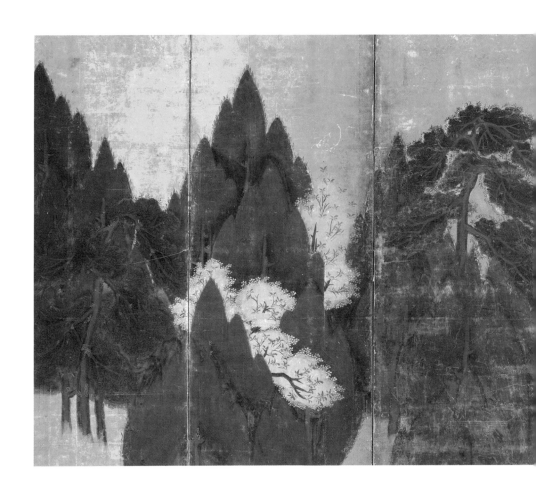

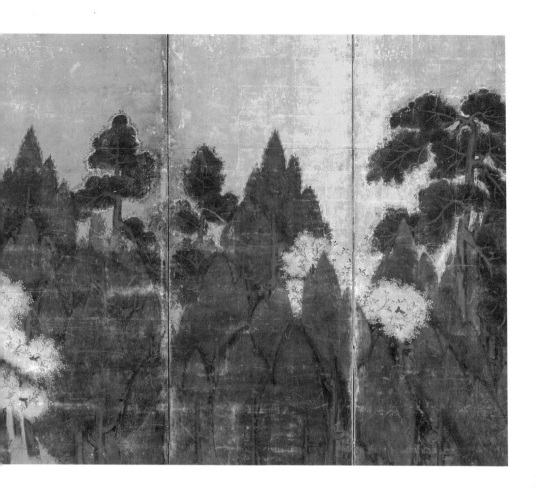

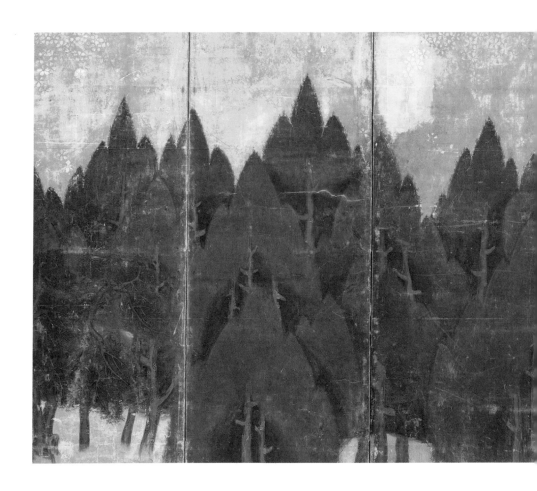

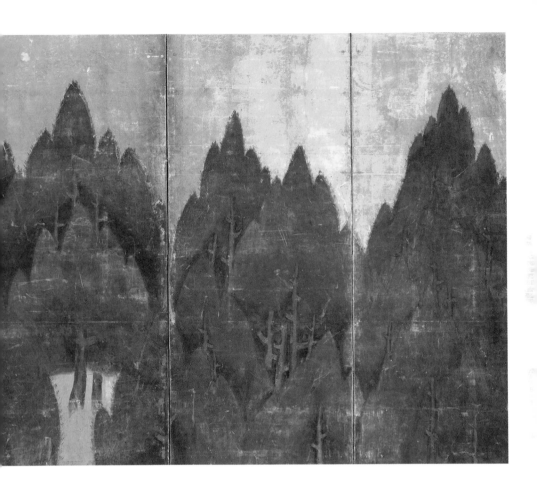

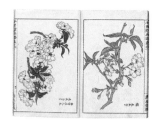

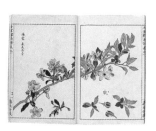

Taisei shinsha fu, vol. 1: 48–49, Kondō Hideari, Meiji era, 1888, each page 30.7 × 21.3, *fukurotoji* binding, woodblock-printed book; ink and color on paper. Purchase—The Gerhard Pulverer Collection, Museum funds, Friends of the Freer and Sackler Galleries and the Harold P. Stern Memorial fund in appreciation of Jeffrey P. Cunard and his exemplary service to the Galleries as chair of the Board of Trustees (2003–2007), FSC-GR-780.372.1_26

Taisei shinsha fu, vol. 1: 50–51, Kondō Hideari, Meiji era, 1888, each page 30.7 × 21.3, *fukurotoji* binding, woodblock-printed book; ink and color on paper. Purchase—The Gerhard Pulverer Collection, Museum funds, Friends of the Freer and Sackler Galleries and the Harold P. Stern Memorial fund in appreciation of Jeffrey P. Cunard and his exemplary service to the Galleries as chair of the Board of Trustees (2003–2007), FSC-GR-780.372.1_27

Taisei shinsha fu, vol. 1: 52–53, Kondō Hideari, Meiji era, 1888, each page 30.7 × 21.3, *fukurotoji* binding, woodblock-printed book; ink and color on paper. Purchase—The Gerhard Pulverer Collection, Museum funds, Friends of the Freer and Sackler Galleries and the Harold P. Stern Memorial fund in appreciation of Jeffrey P. Cunard and his exemplary service to the Galleries as chair of the Board of Trustees (2003–2007),FSC-GR-780.372.1_28

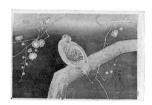

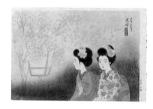

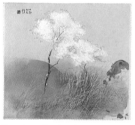

Dove on Cherry Plum Branch, Kōei, Showa era, ca. 1930, 26.3 × 40.6, woodblock print; ink and color on paper. Robert O. Muller Collection, S2003.8.3717

Maiko Viewing Cherry Blossoms at Gion, Kosetsu, Taisho era, 1924, 27 × 39.4, woodblock print; ink and color on paper. Robert O. Muller Collection, S2003.8.1415

Cherry Tree, Takeuchi Seiho, Meiji to Showa era, 1891–1955, 39.1 × 43.5, woodblock print; ink and color on paper. Robert O. Muller Collection, S2003.8.2472

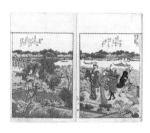

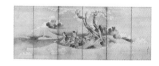

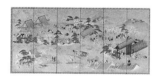

Ehon Sumidagawa ryōgan ichiran, vol. 1: 12–13, Katsushika Hokusai, Edo period, ca. 1805, each page 26.5 × 18.3, *fukurotoji* binding, woodblock-printed book; ink and color on paper. Purchase—The Gerhard Pulverer Collection, Museum funds, Friends of the Freer and Sackler Galleries and the Harold P. Stern Memorial fund in appreciation of Jeffrey P. Cunard and his exemplary service to the Galleries as chair of the Board of Trustees (2003–2007), FSC-GR-780.230.1_8

Viewing Cherry Blossoms, attributed to Katsushika Hokusai, Edo period, ca. 1820s–1830s, 82.4 × 218.3, ink and color on paper. Gift of Charles Lang Freer, F1903.143

Viewing Cherry Blossoms at Ueno Park, Hishikawa Moronobu, Edo period, 17th century, 179.9 × 382.3, six-panel folding screen; ink, color, and gold on paper. Gift of Charles Lang Freer, F1906.267

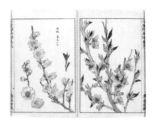

Taisei shinsha fu, vol. 1: 46–47, Kondō Hideari, Meiji era, 1888, each page 30.7 × 21.3, *fukurotoji* binding, woodblock-printed book; ink and color on paper. Purchase—The Gerhard Pulverer Collection, Museum funds, Friends of the Freer and Sackler Galleries and the Harold P. Stern Memorial fund in appreciation of Jeffrey P. Cunard and his exemplary service to the Galleries as chair of the Board of Trustees (2003–2007), FSC-GR-780.372.1_25

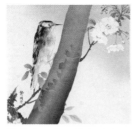

Woodpecker on Cherry, Okuhara Seiko, 23.8 × 24.8, woodblock print; ink and color on paper. Robert O. Muller Collection, S2003.8.2117

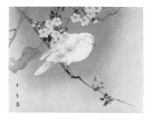

Dove in Cherry Tree, Hotei, late 19th–early 20th century, 20.5 × 26.8, woodblock print; ink and color on paper. Robert O. Muller Collection, S2003.8.151

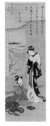

Interior: A Courtesan Writing, Another Looking On, Katsushika Hokusai, Edo period, 88.8 × 30.7, color and gold on silk panel. Gift of Charles Lang Freer, F1903.128

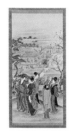

Parties of Men and Women Looking at Cherry Blossoms, Katsushika Hokusai, Edo period, 222.9 × 73.8, color on paper. Gift of Charles Lang Freer, F1903.125

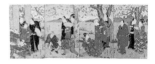

Actors Viewing Cherry Blossoms, Hokushu, Edo period, ca. early 19th century, 37.8 × 99.5, woodblock print; ink and colors on paper. Gift of Gregory T. Kruglak, S1994.56a-d

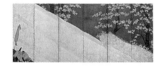

Cherry Blossoms, a High Fence, and Retainers, style of Tawaraya Sotatsu, Edo period, 1590–1640, 165.4 × 378, six-panel folding screen; ink, color, gold, and silver on paper. Gift of Charles Lang Freer, F1903.101

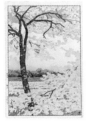

Snow, Moon, and Flowers, Takahashi Shotei, Taisho era, 1922, 35.9 × 24.1, woodblock print; ink and color on paper. Robert O. Muller Collection, S2003.8.2347

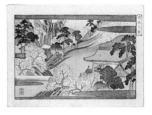

Tokiwa no taki, vol. 1: 12–13, Toyota Hokkei, Takashima Chiharu, Edo period, 1833, each page 25.2 × 17.4, *fukurotoji* binding, woodblock-printed book; ink and color on paper. Purchase—The Gerhard Pulverer Collection, Museum funds, Friends of the Freer and Sackler Galleries and the Harold P. Stern Memorial fund in appreciation of Jeffrey P. Cunard and his exemplary service to the Galleries as chair of the Board of Trustees (2003–2007), FSC-GR-780.211_8

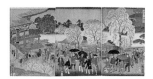

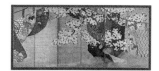

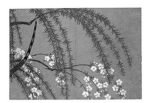

The Buddhist Temple Asakusa Kinryuzan, Utagawa Hiroshige II, Edo period, 1861, 36.3 × 74.3, woodblock print; ink and colors on paper. Bequest of Florence Leonhart, S2007.2a-c

Wind Curtain and Cherry Tree, Edo period, 17th century, 148.1 × 341.1, six-panel folding screen; ink, color, and gold on paper. Gift of Charles Lang Freer, F1897.3

Momoyo gusa, vol. 2: 6–7, Kamisaka Sekka, Meiji era, 1909, each page 30.2 × 22.4, *gajōsō* binding; woodblock printed; ink, color, and mica on paper. Purchase—The Gerhard Pulverer Collection, Museum funds, Friends of the Freer and Sackler Galleries and the Harold P. Stern Memorial fund in appreciation of Jeffrey P. Cunard and his exemplary service to the Galleries as chair of the Board of Trustees (2003–2007), FSC-GR-780.145.2_005

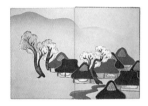

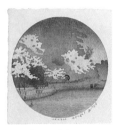

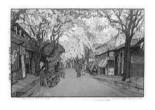

Momoyo gusa, vol. 3: 4–5, Kamisaka Sekka, Meiji era, 1909, each page 30.2 × 22.4, *gajōsō* binding, woodblock-printed book; ink, color, and mica on paper. Purchase—The Gerhard Pulverer Collection, Museum funds, Friends of the Freer and Sackler Galleries and the Harold P. Stern Memorial fund in appreciation of Jeffrey P. Cunard and his exemplary service to the Galleries as chair of the Board of Trustees (2003–2007), FSC-GR-780.145.3_4

Spring Shower at Shiba Park, Kawase Hasui, Taisho era, 1921, 26 × 26, woodblock print; ink and color on paper. Robert O. Muller Collection, S2003.8.610

Avenue of Cherry Trees, Yoshida Hiroshi, Showa era, 1935, 27 × 40.2, woodblock print; ink and color on paper. Purchase and partial gift of H. Ed Robison, S2000.33

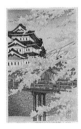

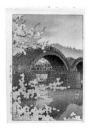

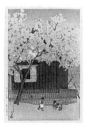

Cherry Blossoms at Himeji Castle, Kawase Hasui, Showa era, 1930s, 14.4 × 9.3, woodblock print; ink and color on paper. Robert O. Muller Collection, S2003.8.1018

Spring at Kintai Bridge, Kawase Hasui, Showa era, 1937, 28.9 × 19.8, woodblock print; ink and color on paper. Robert O. Muller Collection, S2003.8.875

Spring in Mount Atago, Kawase Hasui, Taisho era, 1921, 38 × 26.5, woodblock print; ink and color on paper. Robert O. Muller Collection, S2003.8.623

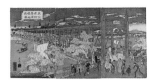

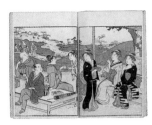

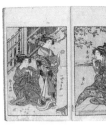

Azumabashi in Cherry Blossom Time, Tankei, Meiji era, 1900, 35.8 × 71.4, woodblock print; ink and color on paper. Robert O. Muller Collection, S2003.8.2503

Ehon sakae gusa, vol. 1: 22–23, Katsukawa Shunchō, Edo period, 1790, each page 21.6 × 15.2, *fukurotoji* binding, woodblock-printed book; ink and color on paper. Purchase—The Gerhard Pulverer Collection, Museum funds, Friends of the Freer and Sackler Galleries and the Harold P. Stern Memorial fund in appreciation of Jeffrey P. Cunard and his exemplary service to the Galleries as chair of the Board of Trustees (2003–2007), FSC-GR-780.153_013

Seirō bijin awase sugata kagami, vol. 1: 18–19, Kitao Shigemasa, Katsukawa Shunshō, Edo period, 1776, each page 27.9 × 18.6, *fukurotoji* binding, woodblock-printed book; ink and color on paper. Purchase—The Gerhard Pulverer Collection, Museum funds, Friends of the Freer and Sackler Galleries and the Harold P. Stern Memorial fund in appreciation of Jeffrey P. Cunard and his exemplary service to the Galleries as chair of the Board of Trustees (2003–2007), FSC-GR-780.167.1_011

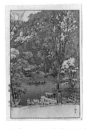

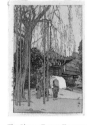

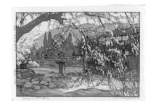

Arashiyama, Yoshida Hiroshi, Showa era, 1935, 37.5 × 24.8, woodblock print; ink and color on paper. Robert O. Muller Collection, S2003.8.3540

The Cherry Tree in Kawagoe, Yoshida Hiroshi, Showa era, 1935, 37.5 × 24.3, woodblock print; ink and color on paper. Robert O. Muller Collection, S2003.8.3539

Spring in a Hot Spring, Yoshida Hiroshi, Showa era, 1940, 28.2 × 40.5, woodblock print; ink and color on paper. Gift of Mr. and Mrs. Harold Horowitz, S1988.44

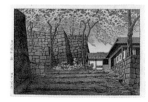

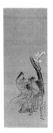

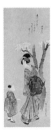

Cherry Blossoms at the Shirakawa Castle Ruins, Kawase Hasui, Showa era, 1946, 26.1 × 39, woodblock print; ink and color on paper. Robert O. Muller Collection, S2003.8.920

A Lady and a Fagot Gatherer under a Cherry Tree, Tawaraya Sori III, Edo period, late 18th–early 19th century, 94 × 35.4, ink and color on silk. Gift of Charles Lang Freer, F1898.103

A Courtesan and Her Attendant under a Cherry Tree, Tawaraya Sori III, Edo period, late 18th–early 19th century, 126.5 × 53.8, color on paper. Gift of Charles Lang Freer, F1898.431

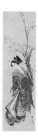
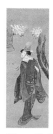
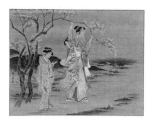

A Courtesan under a Cherry Tree, Katsushika
Hokusai, Edo period, 175.6 × 39.9, color and ink
on silk. Gift of Charles Lang Freer, F1902.100

A Dancer, Kiyohime, a Cherry Tree, and the Bell
of Dojo-ji, Katsushika Hokusai, Edo period,
150 × 29.2, color and ink on silk. Gift of Charles
Lang Freer, F1903.127

Two Girls and a Man under a Cherry Tree, Edo
period, 39.7 × 51.4, hanging scroll; color and
ink on silk panel. Gift of Charles Lang Freer,
F1903.76

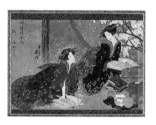
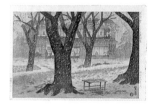
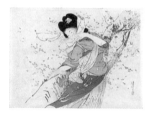

Two Geisha Reading from a Book, Gakutei
Harunobu, Edo period, 19th century,
165.3 × 109.2, hanging scroll; ink, color, gold,
and silver on silk. Gift of Charles Lang Freer,
F1898.8

Cherry Blossom Flurry at Kambayashi Hot
Spring, Kasamatsu Shiro, Showa era, 1939,
26.4 × 38.9, woodblock print; ink and color on
paper. Robert O. Muller Collection, S2003.8.450

Cherry Blossom Flurry, Kaburagi Kiyokata, Meiji
era, 1903, 22.5 x 30.5, woodblock print; ink and
color on paper. Robert O. Muller Collection,
S2003.8.416

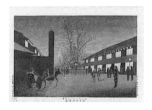
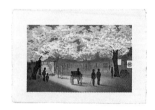
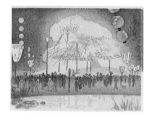

Cherry Blossoms at Night in Shin-Yoshiwara,
Inoue Yasuji, Meiji era, 1880, 20.8 × 32.9, wood-
block print; ink and color on paper.
Robert O. Muller Collection, S2003.8.193

Night Cherries in Full Bloom at Mukōjima,
Kobayashi Kiyochika, Showa era, 1929, 27 × 40.2,
woodblock print; ink and color on paper.
Robert O. Muller Collection, S2003.8.1238

Night Viewing of Cherry Blossom in Gion,
Tokuriki Tomikichiro, Showa era, 12.4 × 16.2,
woodblock print; ink and color on paper.
Robert O. Muller Collection, S2003.8.2518

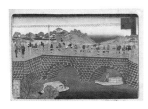

Mansei Bridge and Cherry Blossoms, Watanabe Nobukazu, 1878, 22.5 × 34.3, woodblock print; ink and color on paper. Robert O. Muller Collection, S2003.8.3241

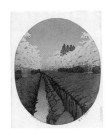

Cherry Blossoms at Night in Koganei, Kawase Hasui, Showa era, 1935, 31.1 × 25.6, woodblock print; ink and color on paper. Robert O. Muller Collection, S2003.8.843

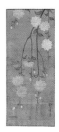

Drooping Cherry Branches in Blossom, attributed to Sakai Hoitsu, Edo period, mid 18th–early 19th century, 65 × 28.2, ink, color, and gold on silk. Gift of Charles Lang Freer. F1898.142

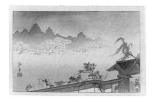

Cherry Blossom in Rain, Shoda Kiroku, Meiji to Taisho era, 22.5 × 36.2, woodblock print; ink and color on paper. Robert O. Muller Collection, S2003.8.2262

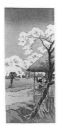

Cherry Blossoms at Sumida River, Takahashi Shotei, Taisho era, 1924–27, 37.3 × 16.4, woodblock print; ink and color on paper. Robert O. Muller Collection, S2003.8.2295

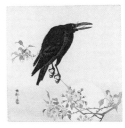

Crow Perched on a Flowering Cherry Branch and Full Moon, Ohara Koson, Meiji era, 1900s, 24.3 × 24.9, woodblock print; ink and color on paper. Robert O. Muller Collection, S2003.8.1974

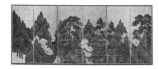

Grove of Cedar, Cryptomeria and Blossoming Cherry, Momoyama period, 1568–1615, 160.7 × 373.1, six-panel screen (left of pair); ink, color, and gold on paper. Gift of Charles Lang Freer, F1903.239

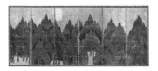

Grove of Cedar, Cryptomeria and Blossoming Cherry, Momoyama period, 1568–1615, 160.7 × 372.9, six-panel screen (right of pair); ink, color, and gold on paper. Gift of Charles Lang Freer, F1903.240

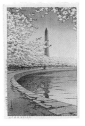

Washington Monument (Potomac Riverbank), Kawase Hasui, Showa era, 1935, 39 × 26, woodblock print; ink on paper. Gift of the Kruglak family in memory of Amy and Ted Kruglak, S1998.159

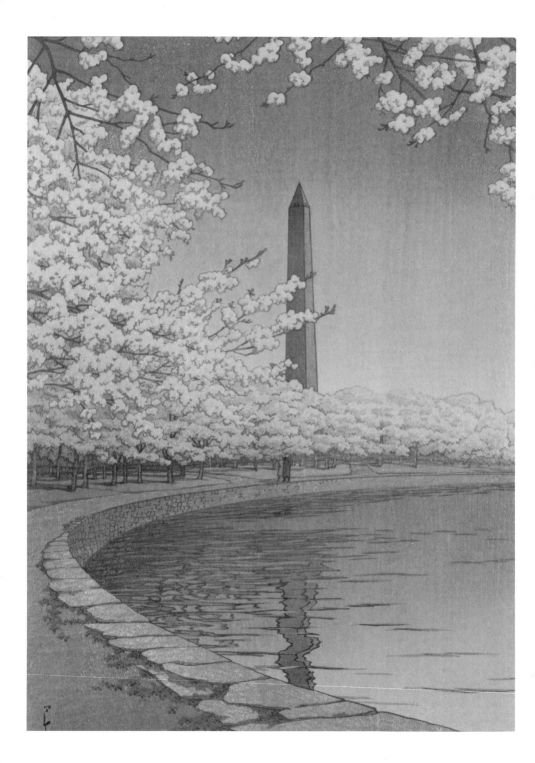

All works are from the collections of the Smithsonian's Freer Gallery of Art and Arthur M. Sackler Gallery, designated in the captions as follows:

F = Freer Gallery of Art
FSC = Freer Study Collection
S = Arthur M. Sackler Gallery

All dimensions are in centimeters, given as height x width.

Fukurotoji is a bookbinding type in which sheets are folded with the printed side out. Folded sheets are stacked, punched along the open edges, and bound with rolled paper cords. The bound "book block" is placed between heavier paper covers and sewn with thread.

Gajōsō is a bookbinding type in which each printed sheet is folded inward and pasted along the outside vertical edges to the back of the next sheet. The first and last sheets are usually pasted to the inside of the front or back cover.

Quotes by Donald Keene from his book *Appreciations of Japanese Culture* (1971; repr., Tokyo: Kodansha, 2002), p. 16.

Photographs by Neil Greentree, Robert Harrell, and John Tsantes, Freer Gallery of Art and Arthur M. Sackler Gallery

James T. Ulak is senior curator of Japanese art, Freer Gallery of Art and Arthur M. Sackler Gallery, Smithsonian Institution

Howard Kaplan is museum writer, Freer Gallery of Art and Arthur M. Sackler Gallery, Smithsonian Institution

First published in the United States in 2015 by

Skira Rizzoli Publications, Inc.
300 Park Avenue South
New York, NY 10010
rizzoliusa.com

in association with

Freer Gallery of Art and the Arthur M. Sackler Gallery
Smithsonian Institution
Washington, DC
asia.si.edu

For Freer Gallery of Art and Arthur M. Sackler Gallery:
Editor: Jane Lusaka

For Skira Rizzoli:
Publisher: Charles Miers
Associate Publisher: Margaret Rennolds Chace
Editor: Loren Olson

Designer: Steven Sarkozy

Copyright © 2015 by Smithsonian Institution, Washington, DC

2018 2019 2020 2021 / 10 9 8 7 6 5 4 3
Library of Congress Control Number: 2014951204
ISBN: 978-0-8478-4522-4

On the cover: *Taisei shinsha fu*, vol. 1: 51, Kondō Hideari, Meiji era, 1888, each page
30.7 × 21.3, *fukurotoji* binding, woodblock-printed book; ink and color on paper.
Purchase—The Gerhard Pulverer Collection, Museum funds, Friends of the Freer
and Sackler Galleries and the Harold P. Stern Memorial fund in appreciation of
Jeffrey P. Cunard and his exemplary service to the Galleries as chair of the Board
of Trustees (2003–2007), FSC-GR-780.372.1_27

On page 4: *Kisho, Nishi-Izu*, Kawase Hasui, Showa era, 1937, 39.1 × 28.3, woodblock
print; ink and color on paper. Robert O. Muller Collection, S2003.8.869

Printed and bound in China